Dream
Catcher
mother nature

An awe inspiring adult colouring book celebrating
the hidden tenderness of the untamed wild
by Christina Rose

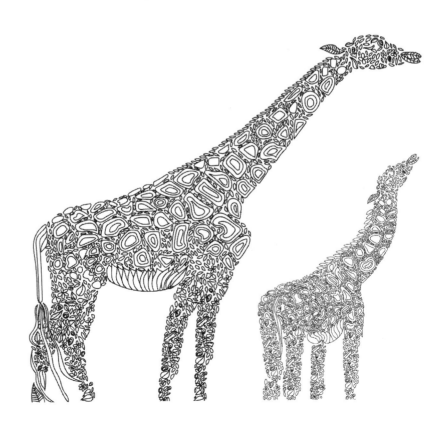

Dream Catcher: mother nature

An awe inspiring adult colouring book celebrating the hidden tenderness of the untamed wild

First published in the United Kingdom in 2015 by
Bell & Mackenzie PUblishing Limited

ISBN: 978-1-910771-55-6

Created by Christina Rose
Contributors: Letitia Clouden

www.bellmackenzie.com

This book belongs to

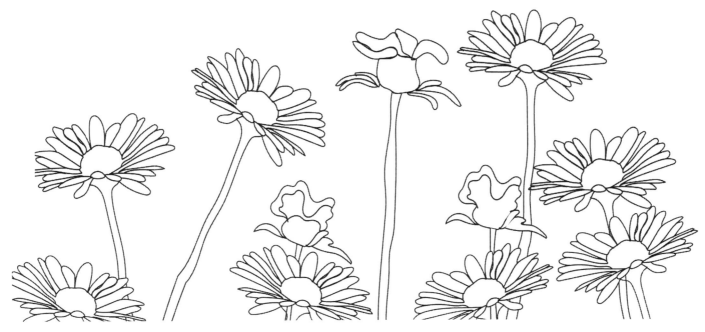

Your deepest roots are in nature. No matter who you are, where you live, or what kind of life you lead, you remain irrevocably linked with the rest of creation.

Charles Co

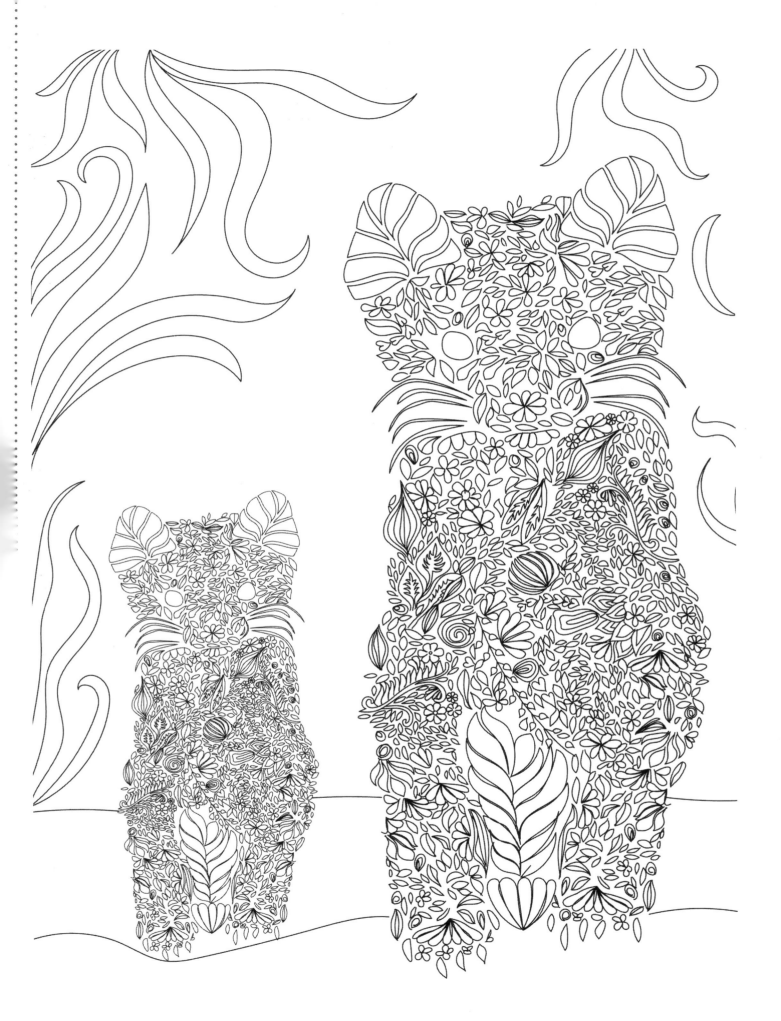

Deep inside, we still have a longing to be reconnected with the nature that shaped our imagination, our language, our song and dance, our sense of the divine.

Janine M. Beny

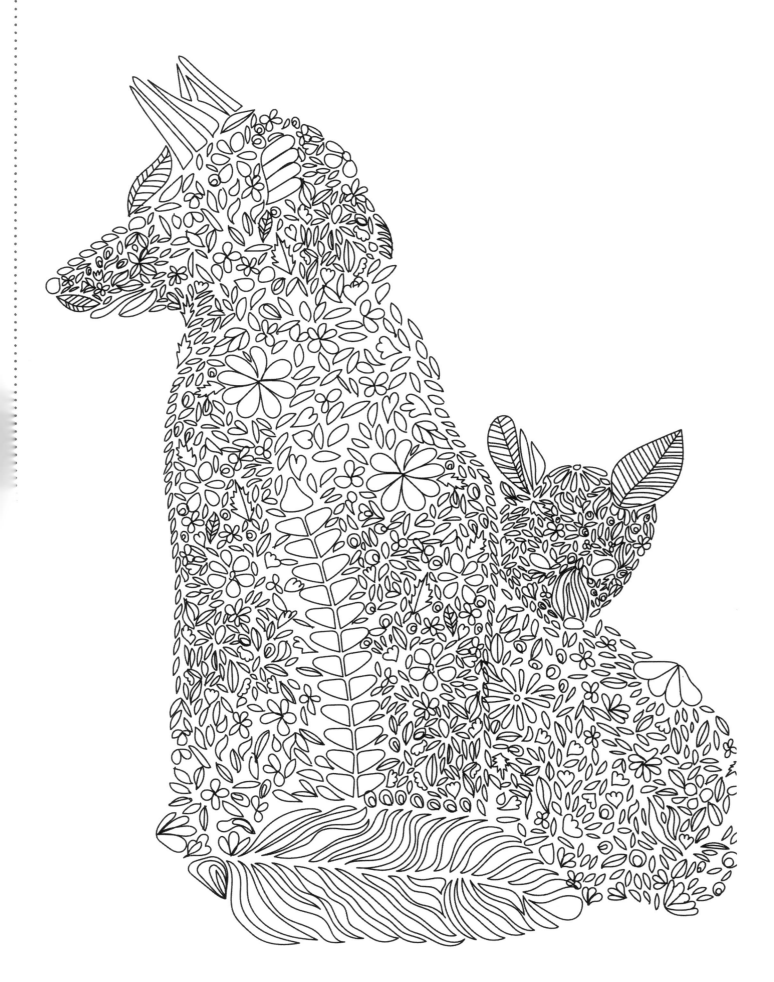

The machine can make everything from a spoon to a landing-craft, a natural joy in earthly living is something it never has and never will be able to manufacture.

Henry Beston

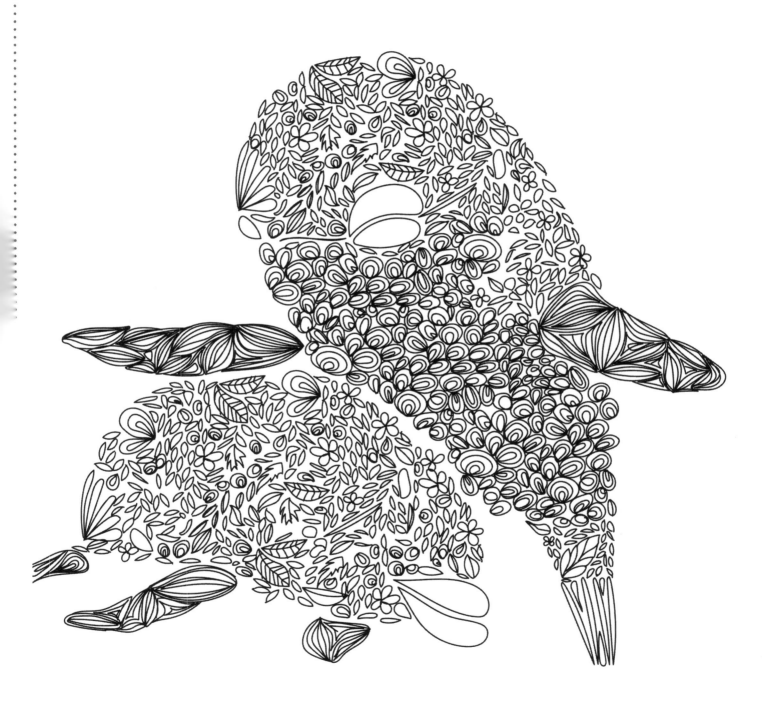

We inter-breathe with the rain forests, we drink from the oceans. They are part of our own body.

Thich Nhat Ha

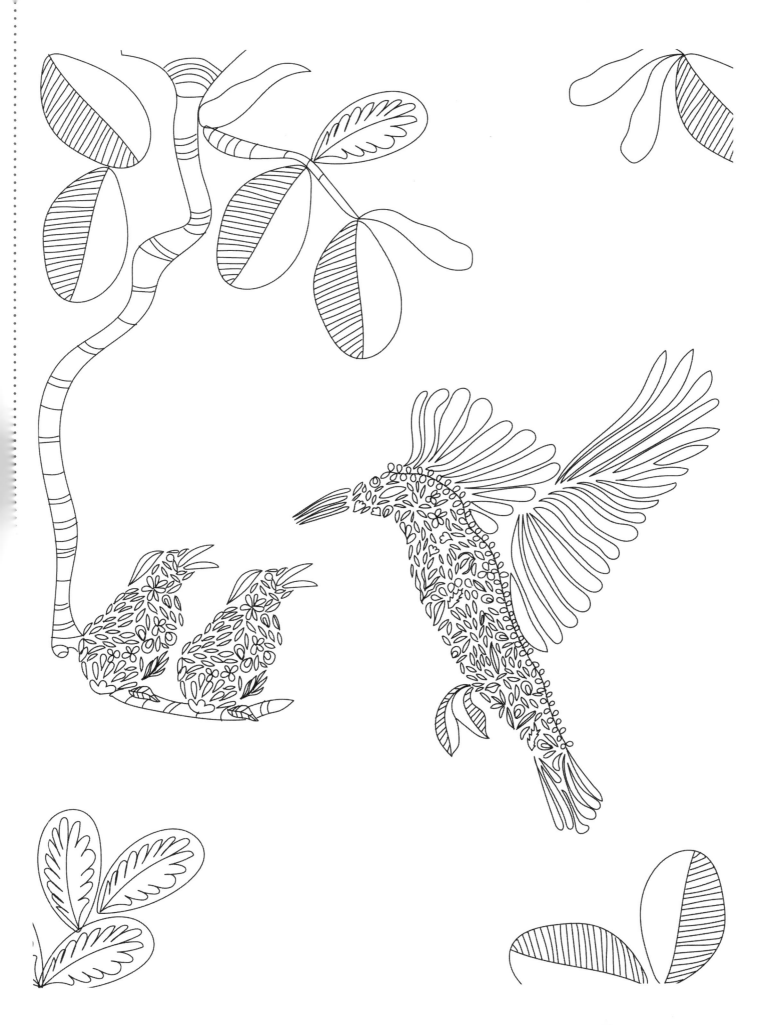

You didn't come into this world. You came out of it, like a wave from the ocean. You are not a stranger here.

Alan Wa

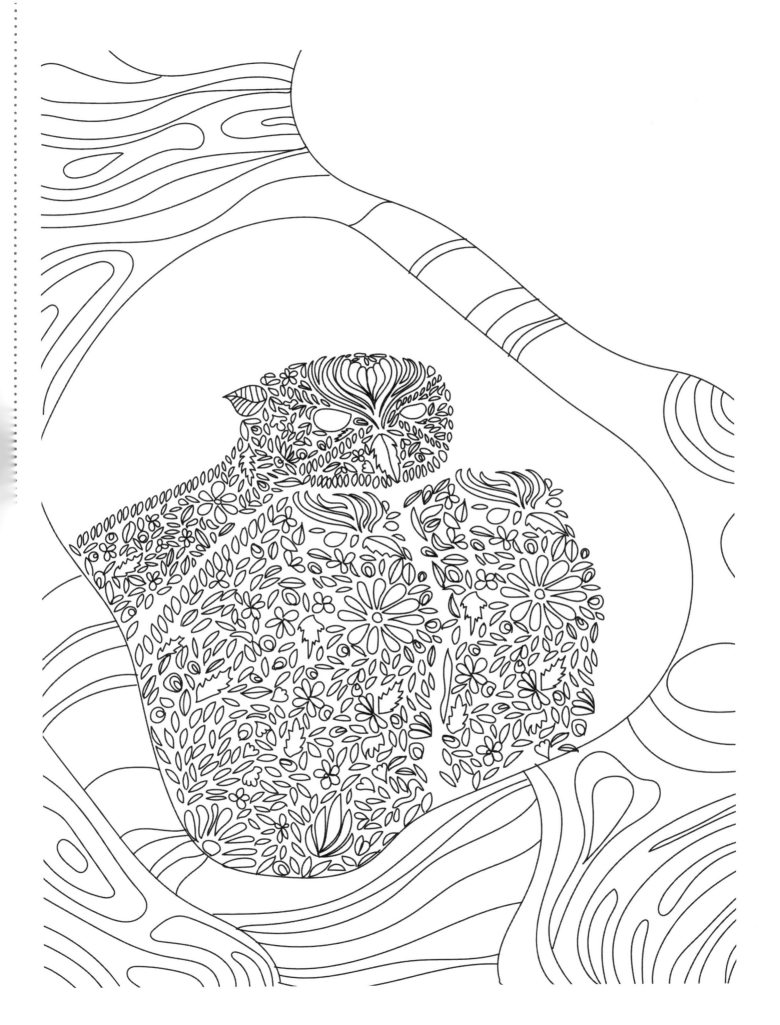

Shall I not have intelligence with the earth? Am I not partly leaves and vegetable mould myself?

Henry David Thore

By viewing nature, nature's handmaid art, makes mighty things from small beginnings grow: Thus fishes first to shipping did impart, their tail the rudder, and their head the prow.

John Dryd

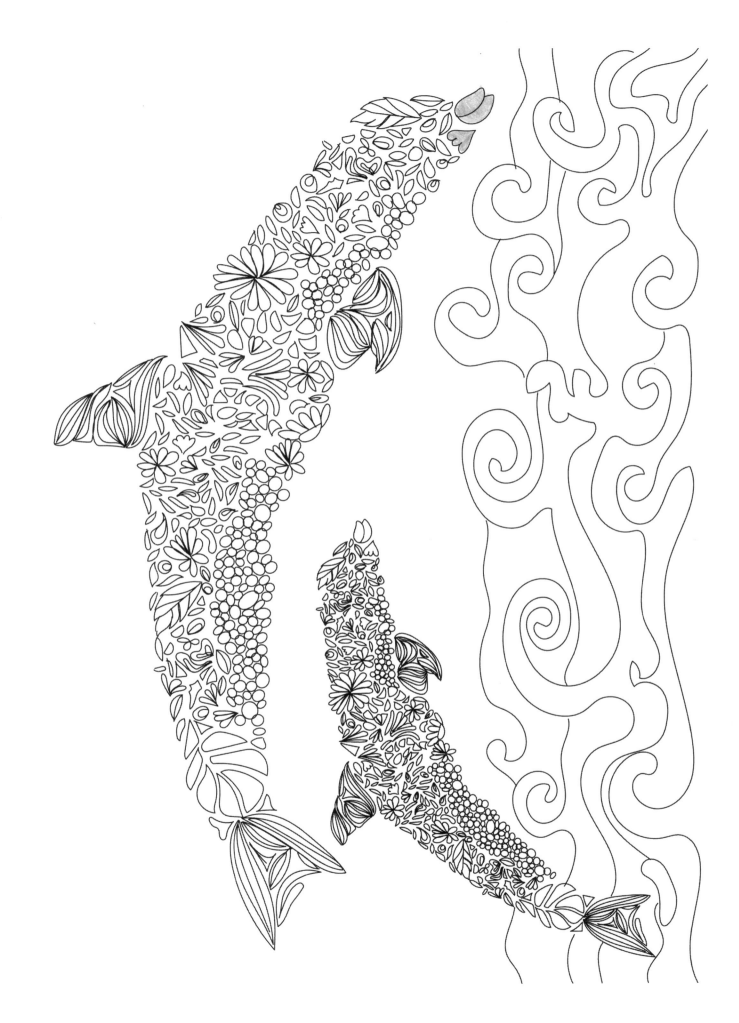

In wilderness I sense the miracle of life, and behind it our scientific accomplishments fade to trivia.

Charles A. Lindbergh

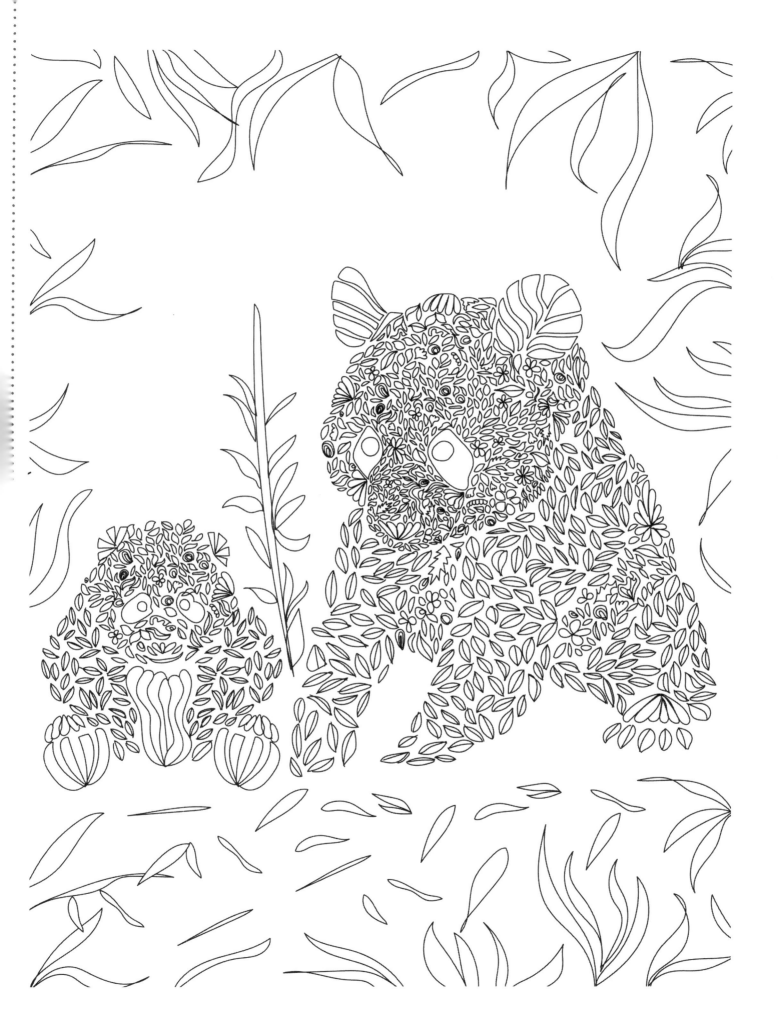

After all, I don't see why I am always asking for private, individual, selfish miracles when there are miracles like white dogwood.

Morrow Lindberg

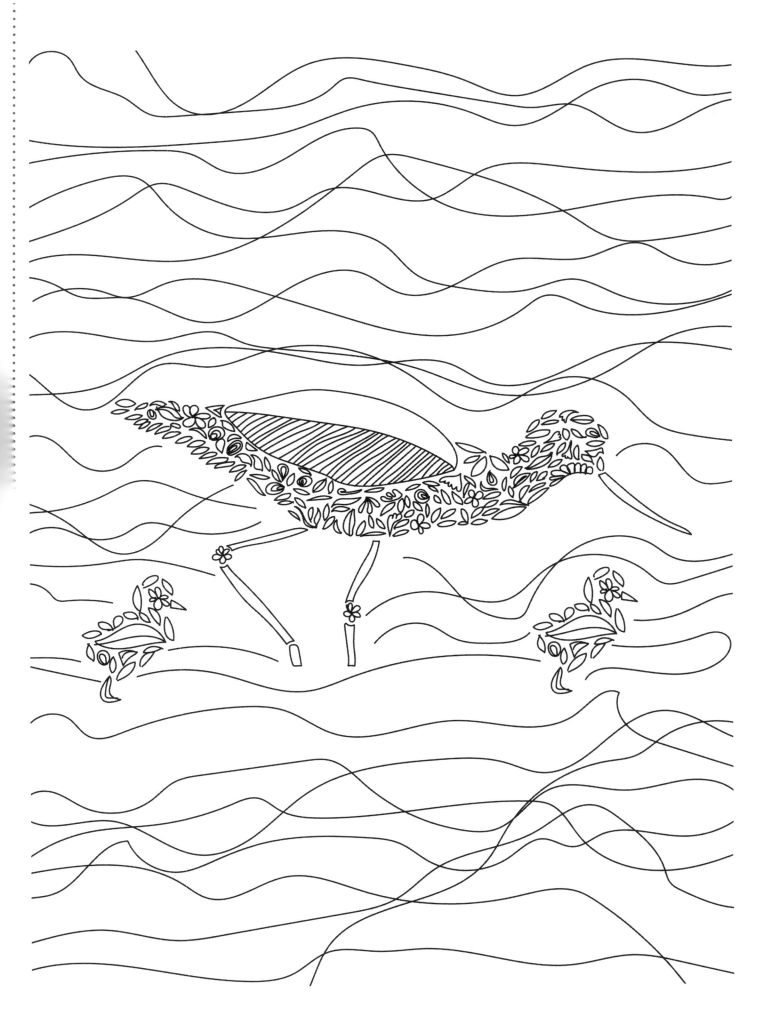

Everybody needs beauty as well as bread, places to play in and pray in, where Nature may heal and cheer and give strength to body and soul alike.

John M

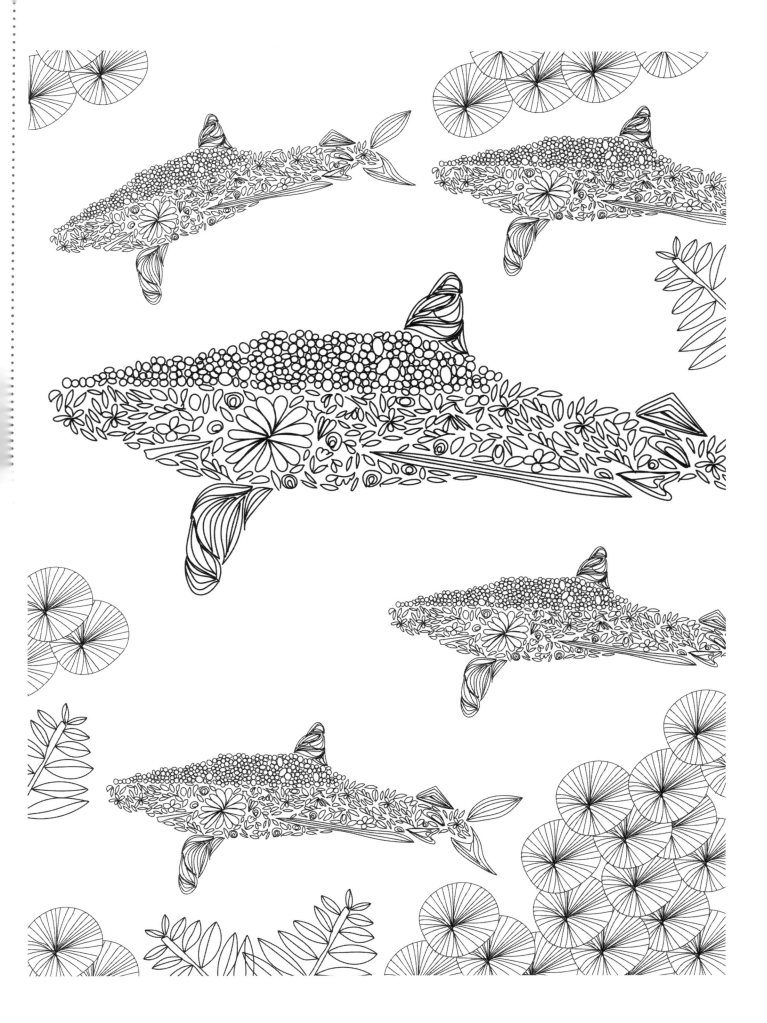

And forget not that the earth delights to feel your bare feet and the winds long to play with your hair.

Kahlil Gibr

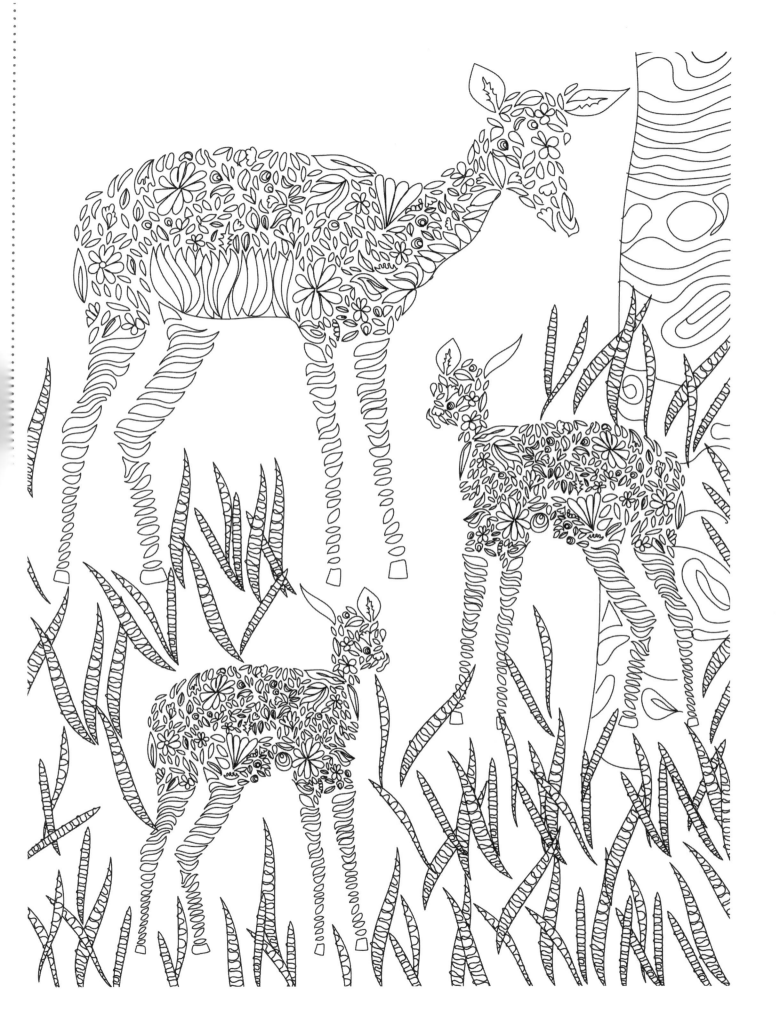

Go out, go out I beg of you, and taste the beauty of the wild. Behold the miracle of the earth, with all the wonder of a child.

Edna Jaqu

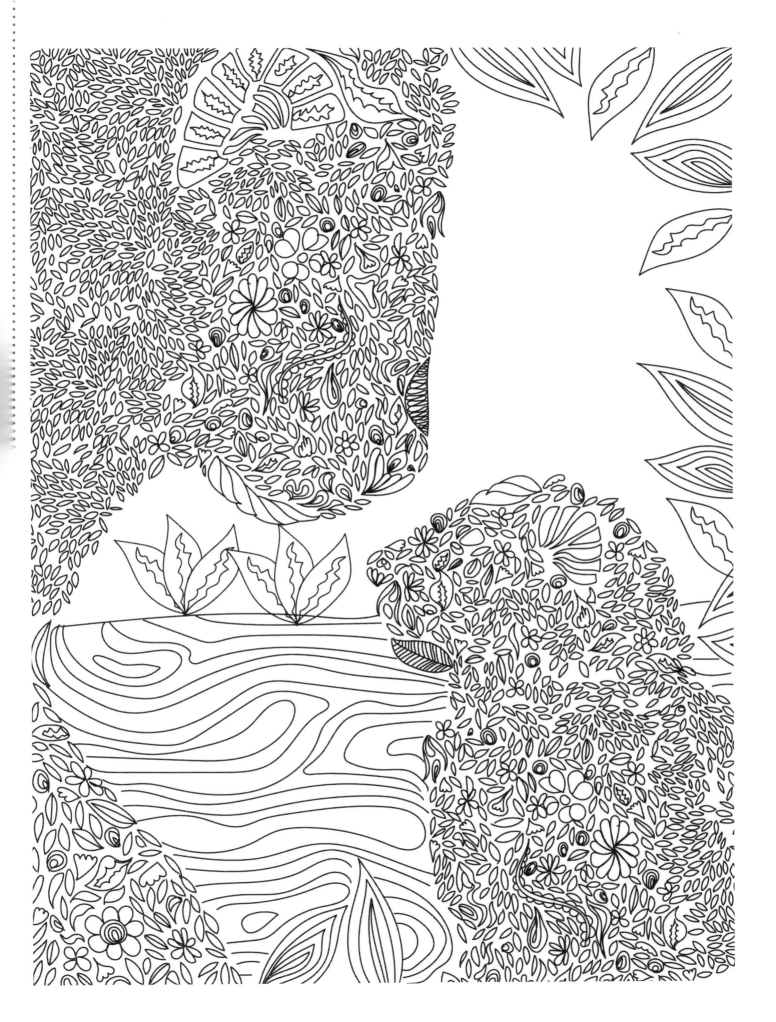

The indescribable innocence of and beneficence of Nature,—of sun and wind and rain, of summer and winter,—such health, such cheer, they afford forever!

Henry David Thore

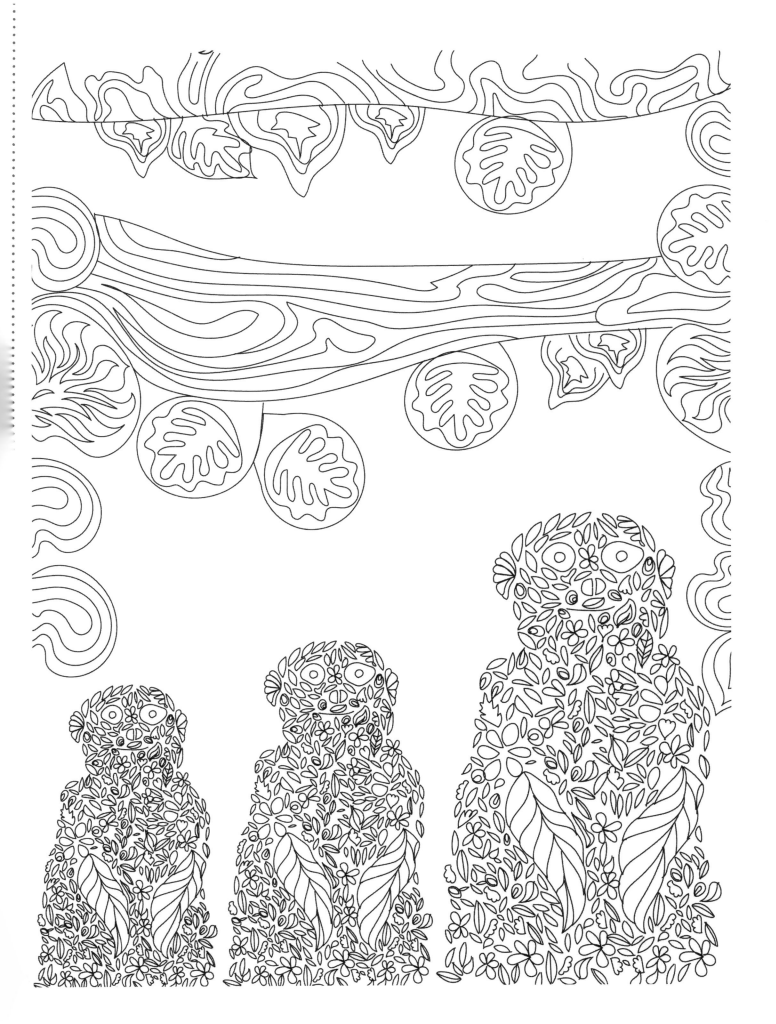

Only spread a fern-frond over a man's head and worldly cares are cast out, and freedom and beauty and peace come in.

John M

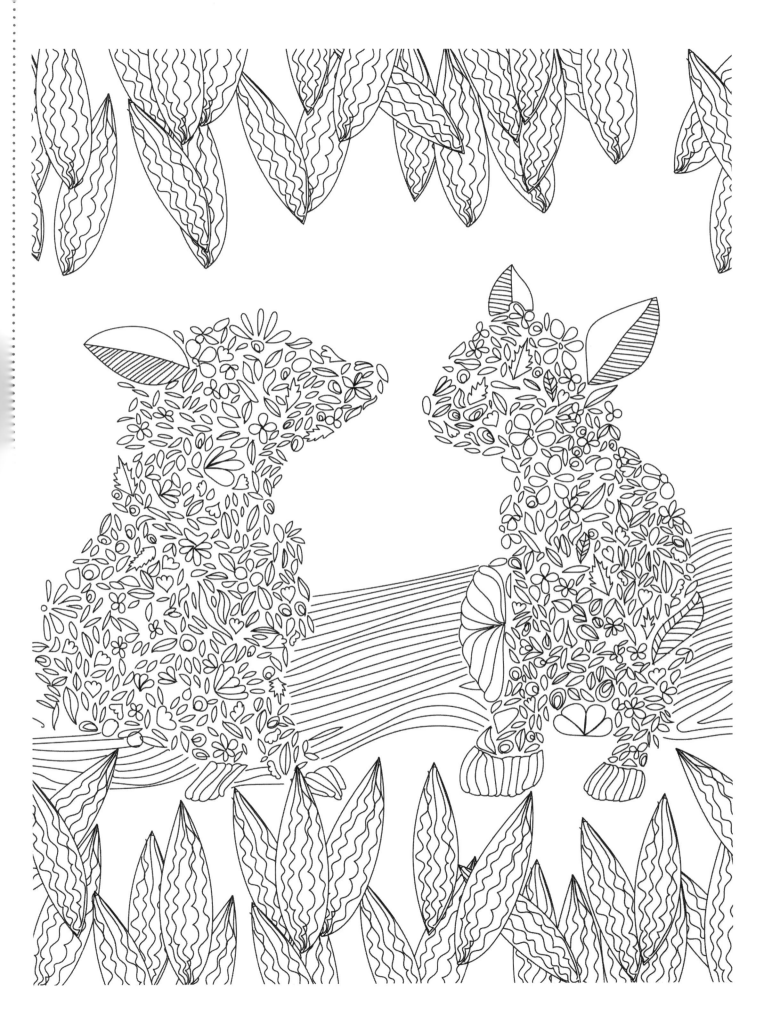

The forest makes your heart gentle. You become one with it... No place for greed or anger there.

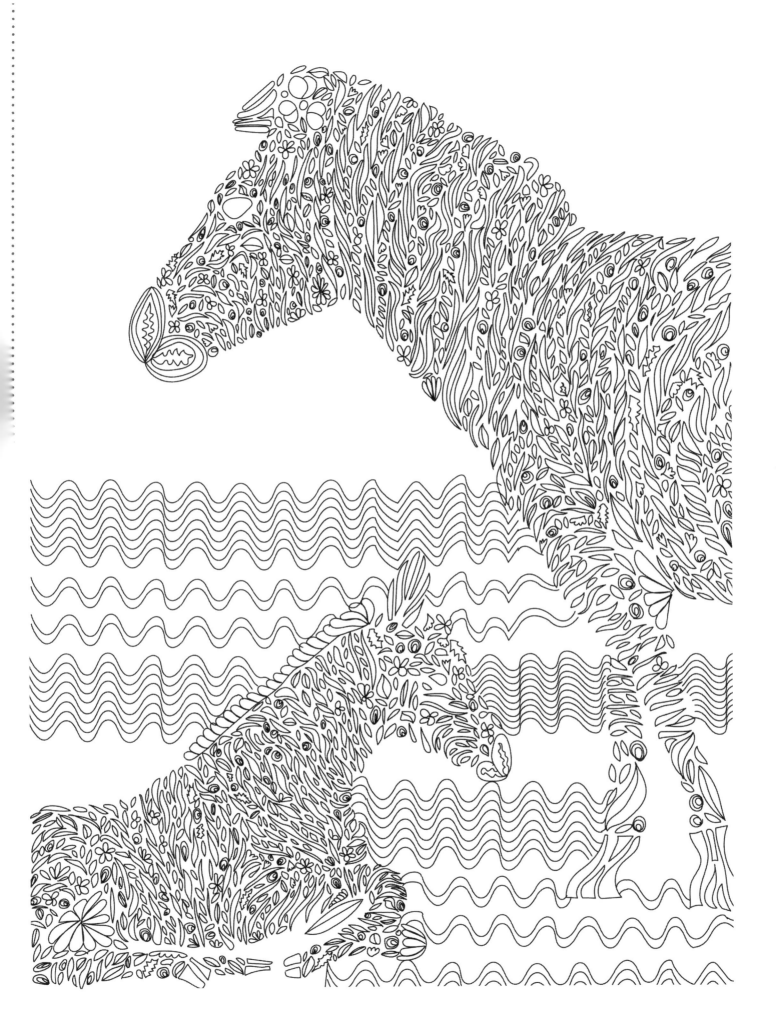

Believe one who knows: you will find something greater in woods than in books. Trees and stones will teach you that which you can never learn from masters.

Saint Bernard de Clairva

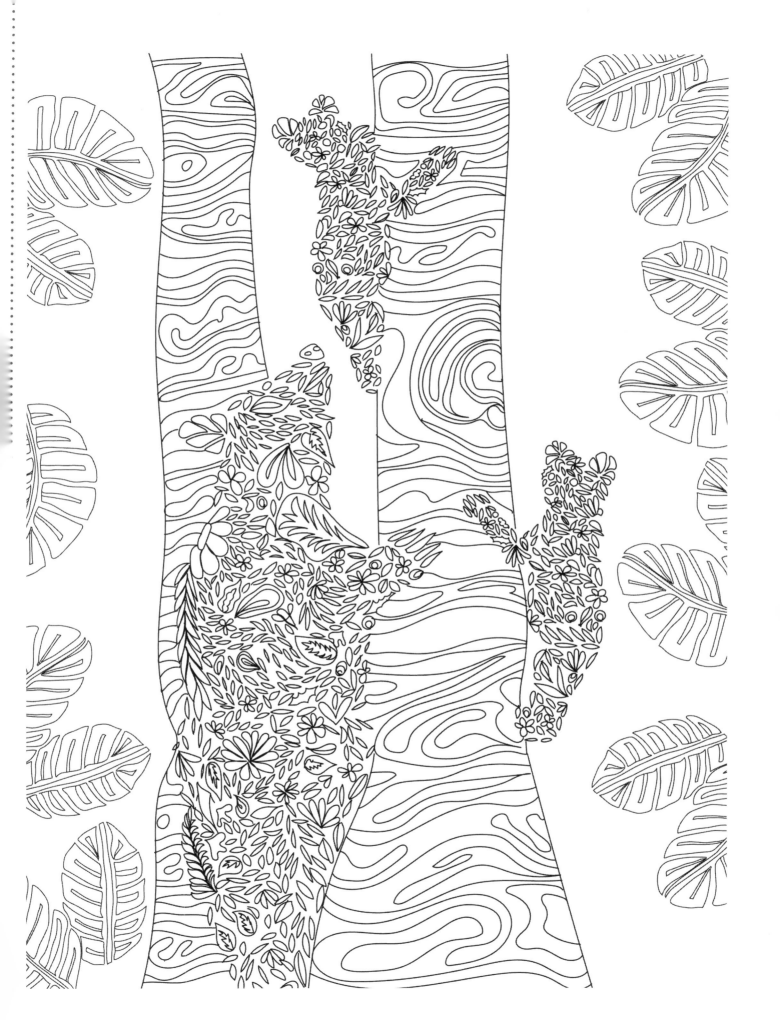

Every child is born a naturalist. His eyes are, by nature, open to the glories of the stars, the beauty of the flowers, and the mystery of life.

R. Sear

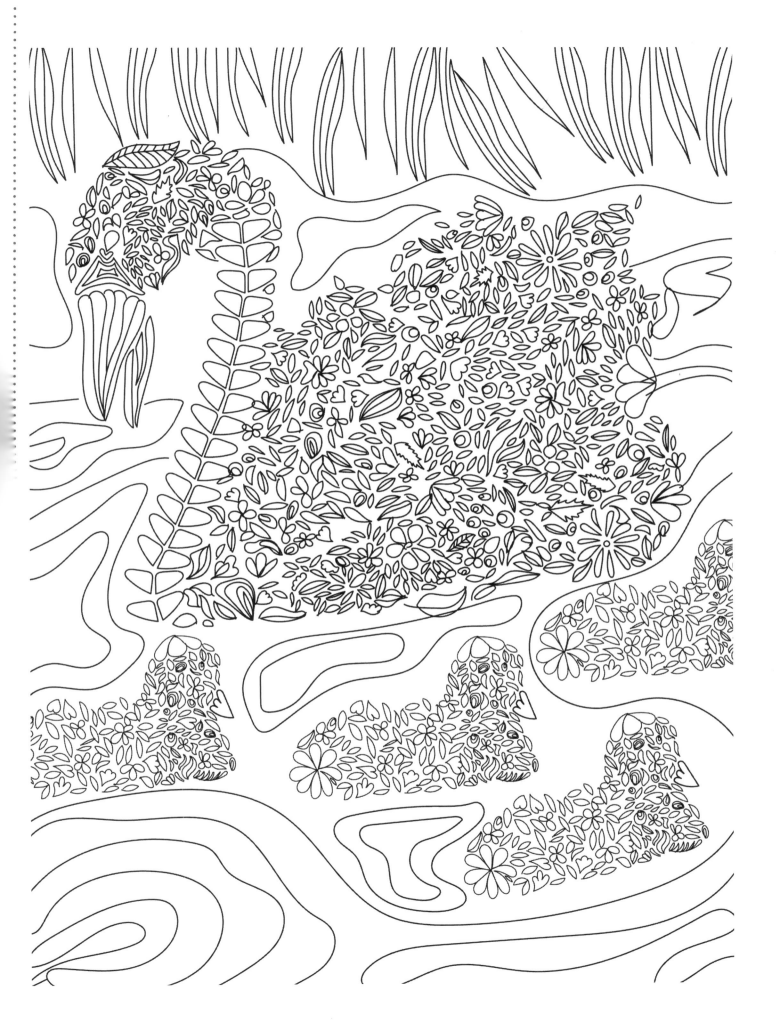

Take them to the woods and hills, and give them the freedom of the meadows; the hills purify those who walk upon them.

Richard Jeffer

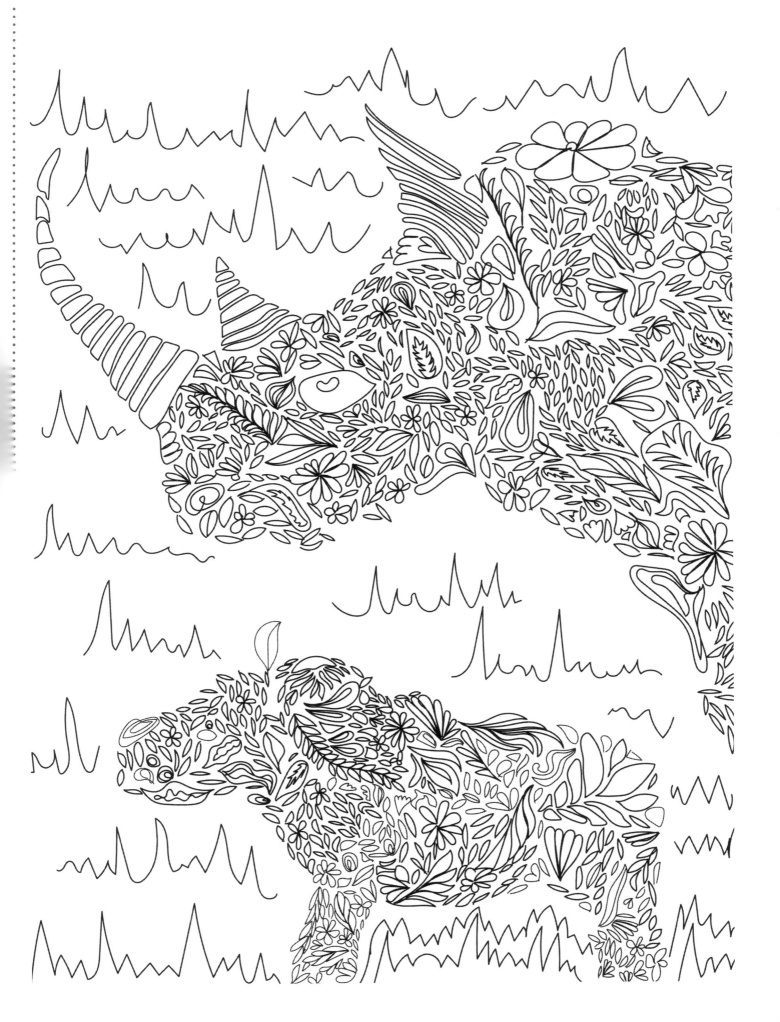

Now I see the secret of the making of the best persons. It is to grow in the open air, and to eat and sleep with the earth.

Walt Whitm

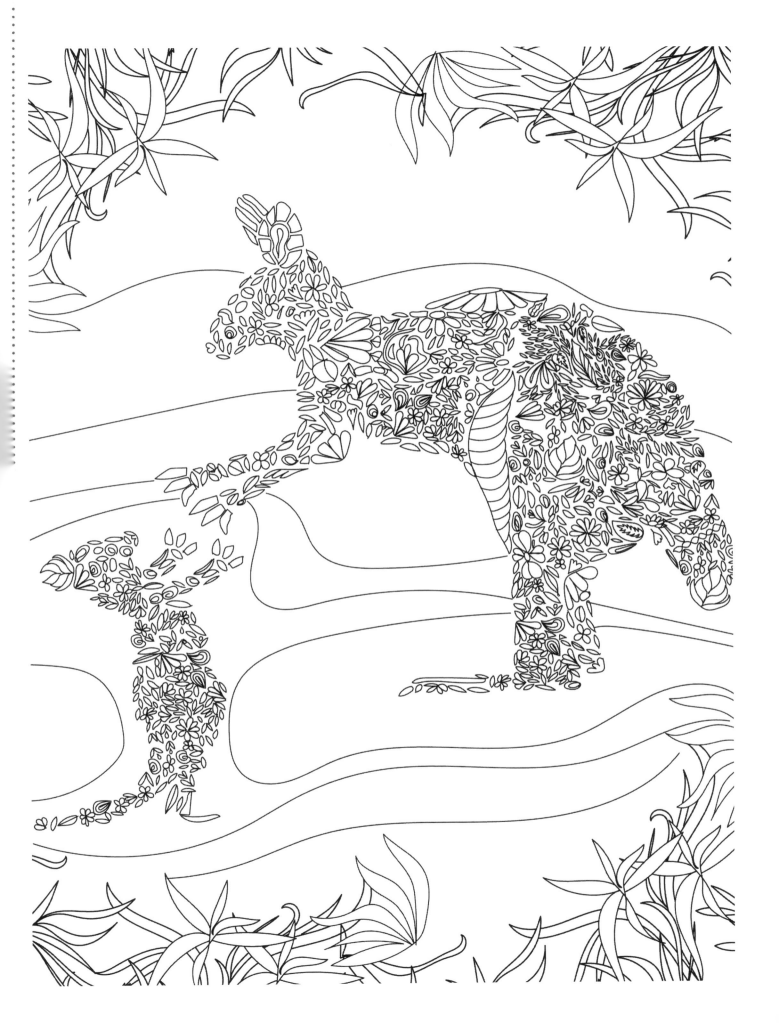

The purpose of life is undoubtedly to know oneself. We cannot do it unless we learn to identify ourselves with all that lives.

Mahatma Gand

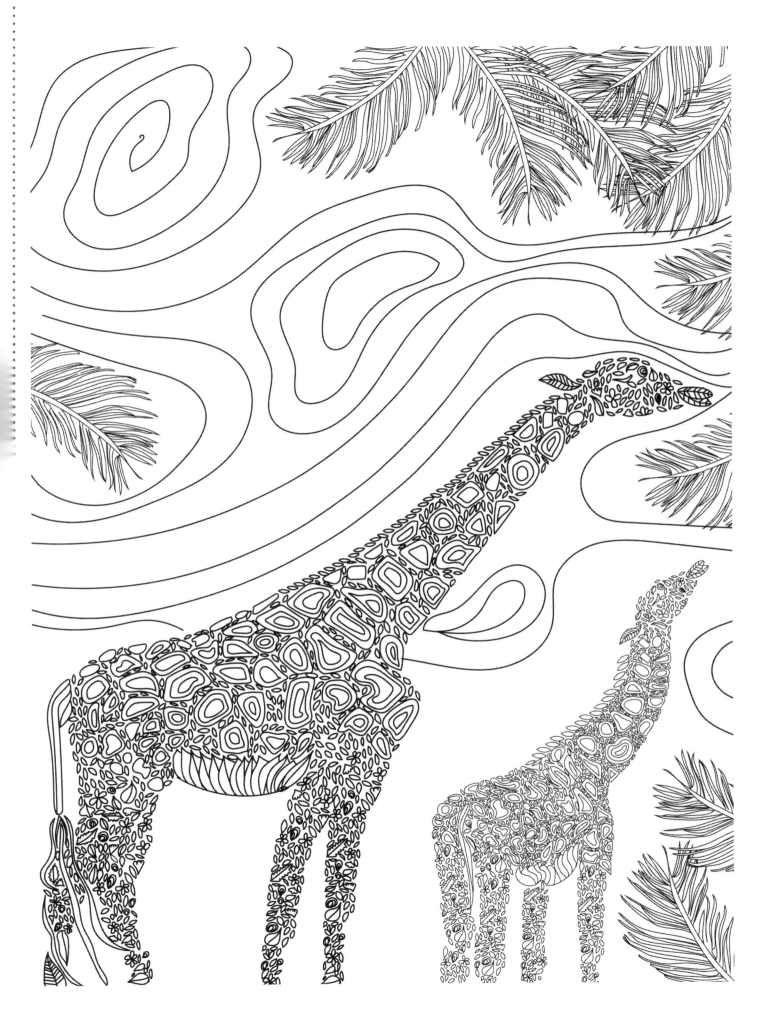

I am in love with this world . . . I have climbed its mountains, roamed its forests, sailed its waters, crossed its deserts, felt the sting of its frosts, the oppression of its heats, the drench of its rains, the fury of its winds, and always have beauty and joy waited upon my goings and comings.

John Burroug

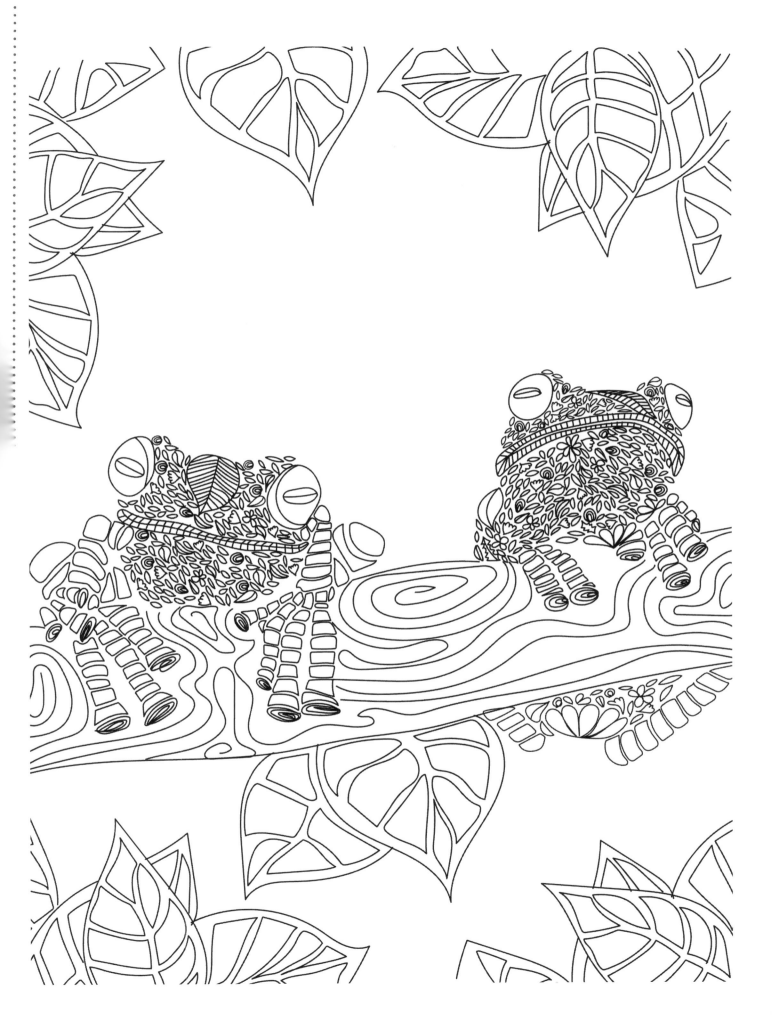

In those vernal seasons of the year, when the air is calm and pleasant, it were an injury and sullenness against Nature not to go out and see her riches, and partake in her rejoicing with heaven and earth.

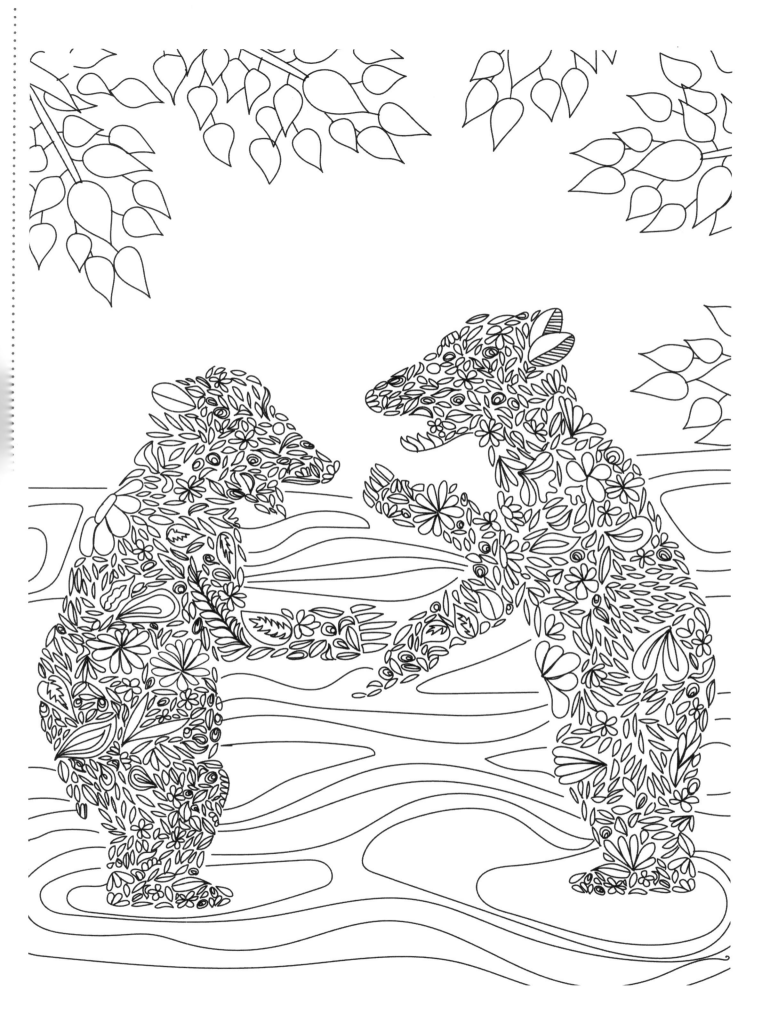

Man is not himself only...He is all that he sees; all that flows to him from a thousand sources...He is the land, the lift of its mountain lines, the reach of its valleys.

Mary Aus

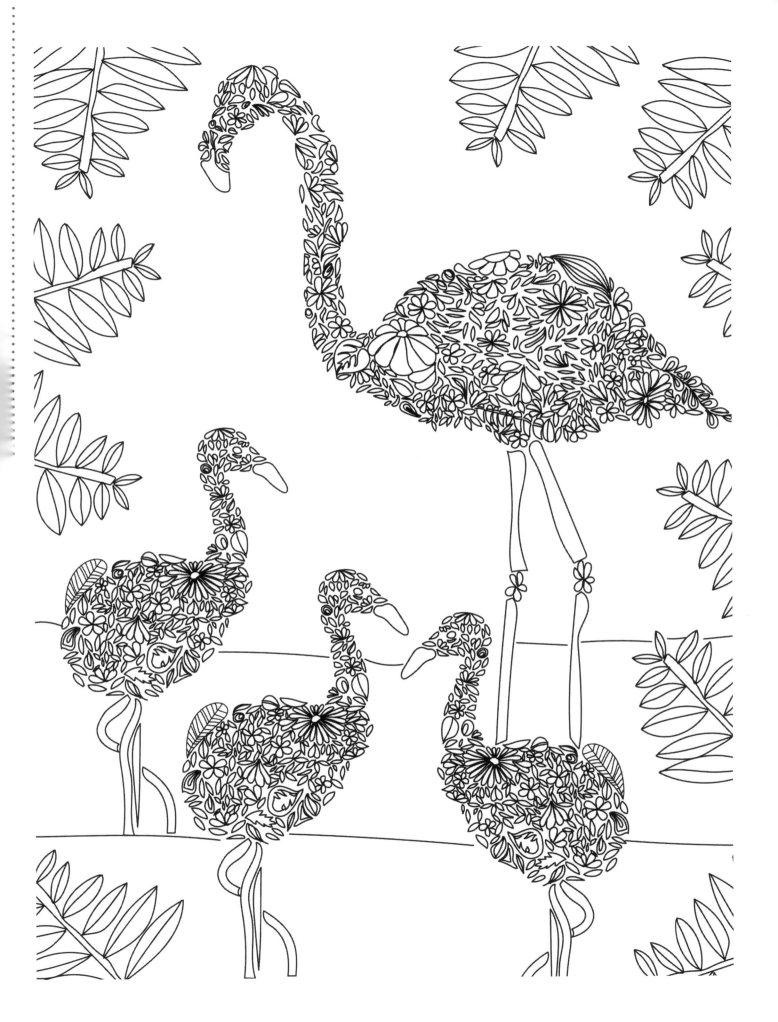

I arise today, through the strength of heaven: Light of sun, radiance of moon, splendour of fire. Speed of lightning, swiftness of wind, depth of sea, stability of earth, firmness of rock.

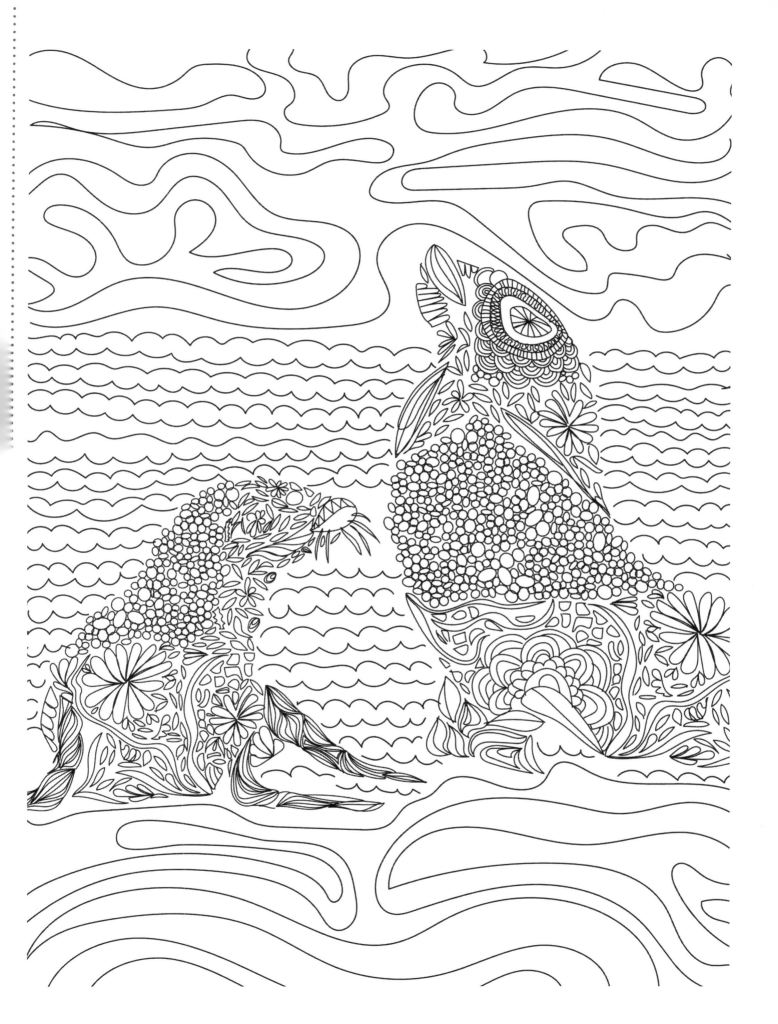

Life is not always perfect. Like a road, it has many bends, ups and down, but that's its beauty.

Amit R

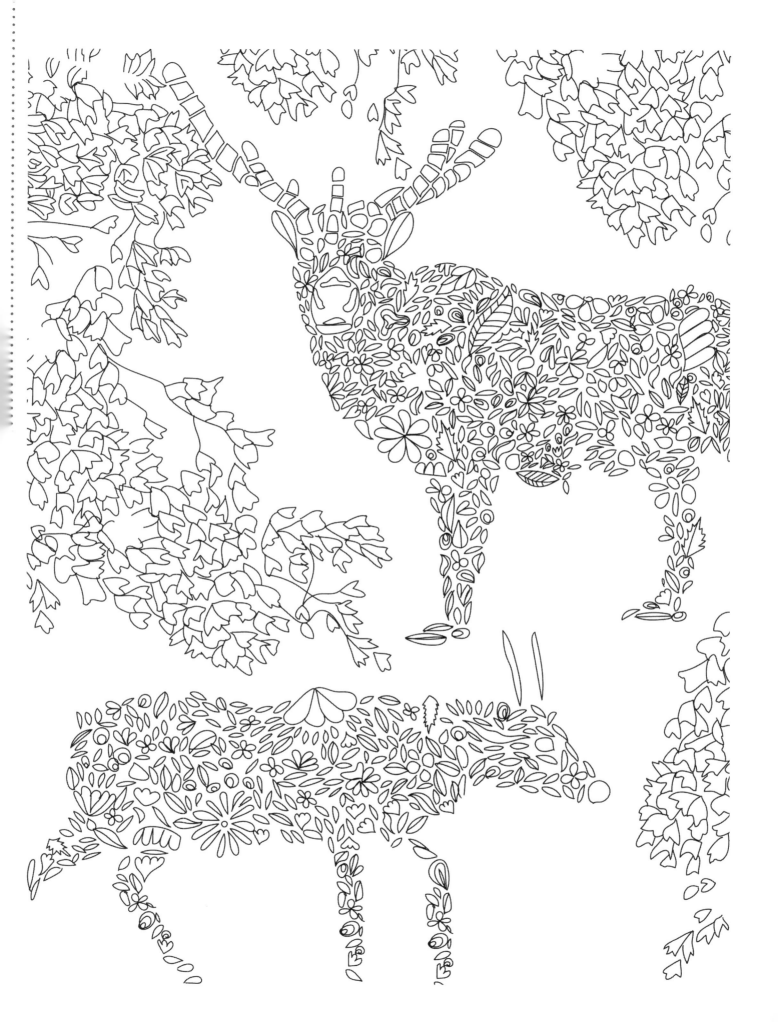

In the woods, we return to reason and faith. There I feel that nothing can befall me in life, - no disgrace, no calamity (leaving me my eyes), which nature cannot repair.

Ralph Waldo Emers

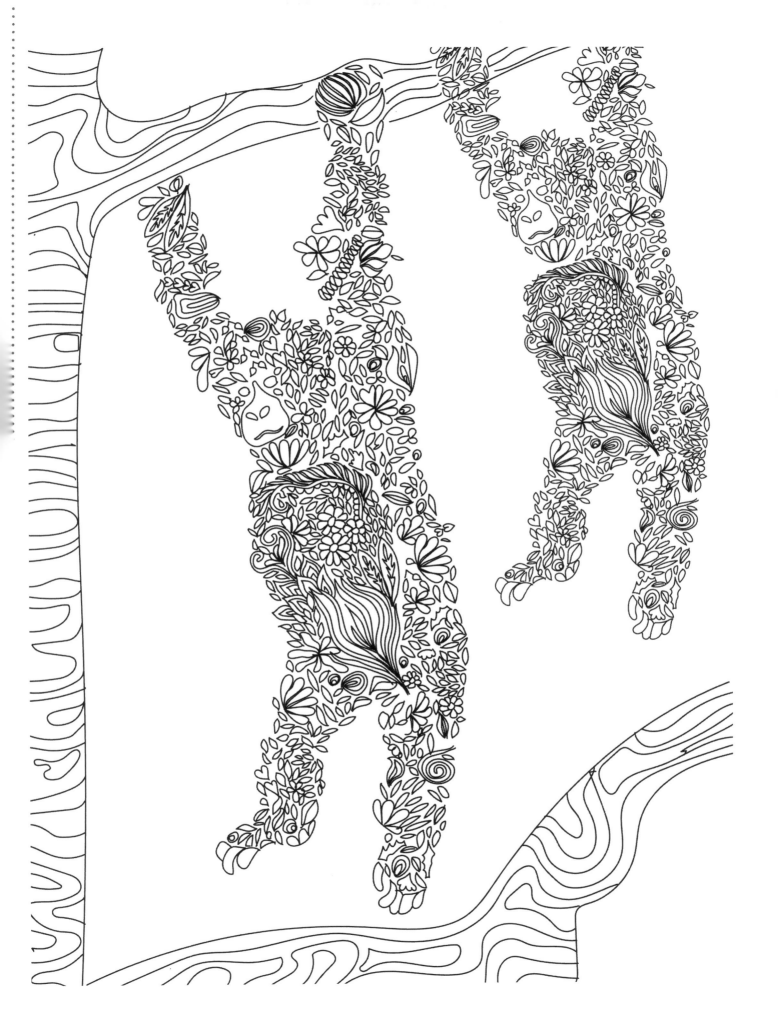

Away from the tumult of motor and mill I want to be care-free; I want to be one with the blossoms and birds, still! I'm weary of doing things, still! I'm weary of doing things, weary of words. I want to be one with the blossoms and birds. I want to be one with the blossoms and birds, weary of words. weary of doing things; weary of doing things;

Edgar A. Gu

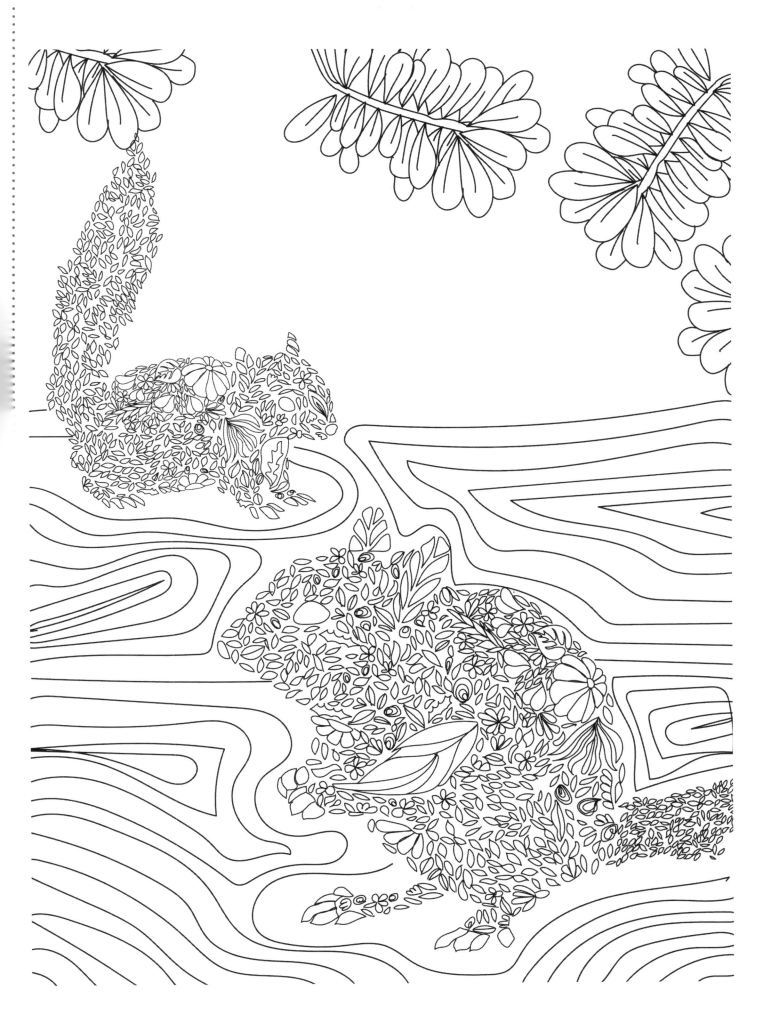

When I hear the coyote wailing to the yellow dawn, my cares fall from me — I am happy.

Hamlin Garla

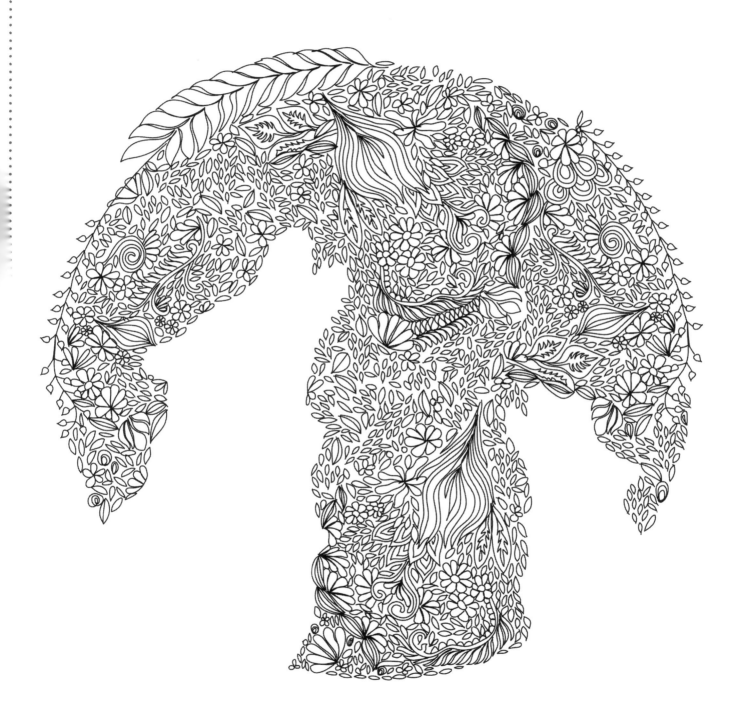

Whenever I have found myself stuck in the ways I relate to things, I return to nature. It is my principal teacher, and I try to open my whole being to what it has to say.

Wynn Bull

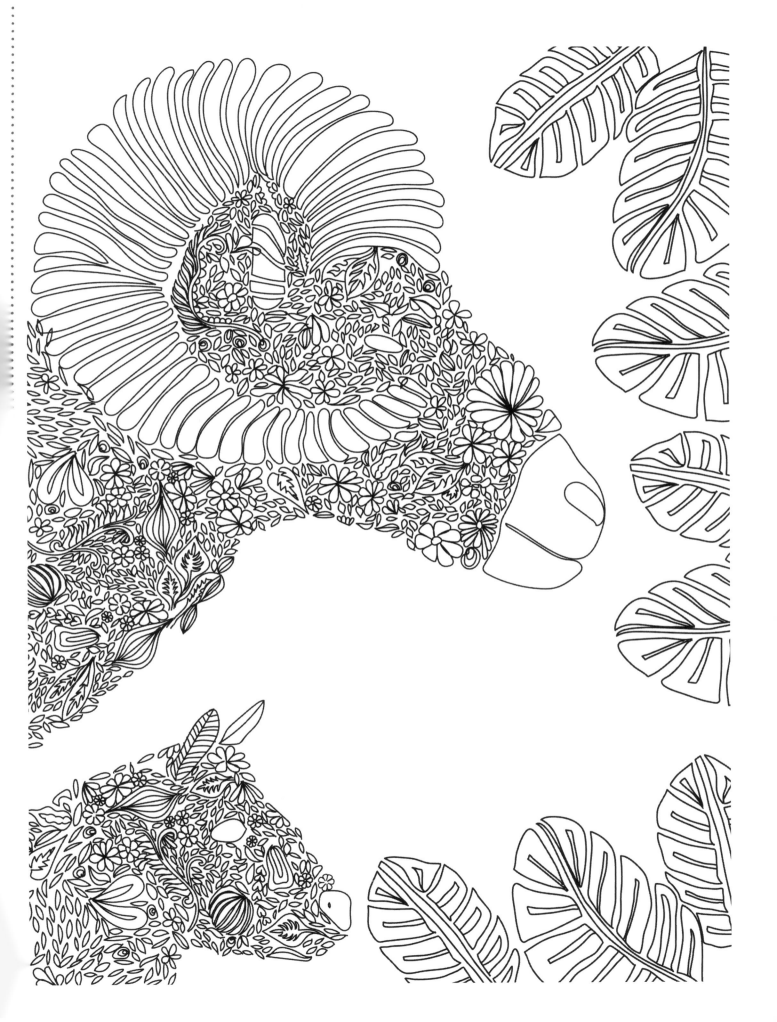

If there is any wisdom running through my life now, in my walking on this earth, it came from listening in the Great Silence to the stones, trees, space, the wild animals, to the pulse of all life as my heartbeat.

Vijali Hamilt

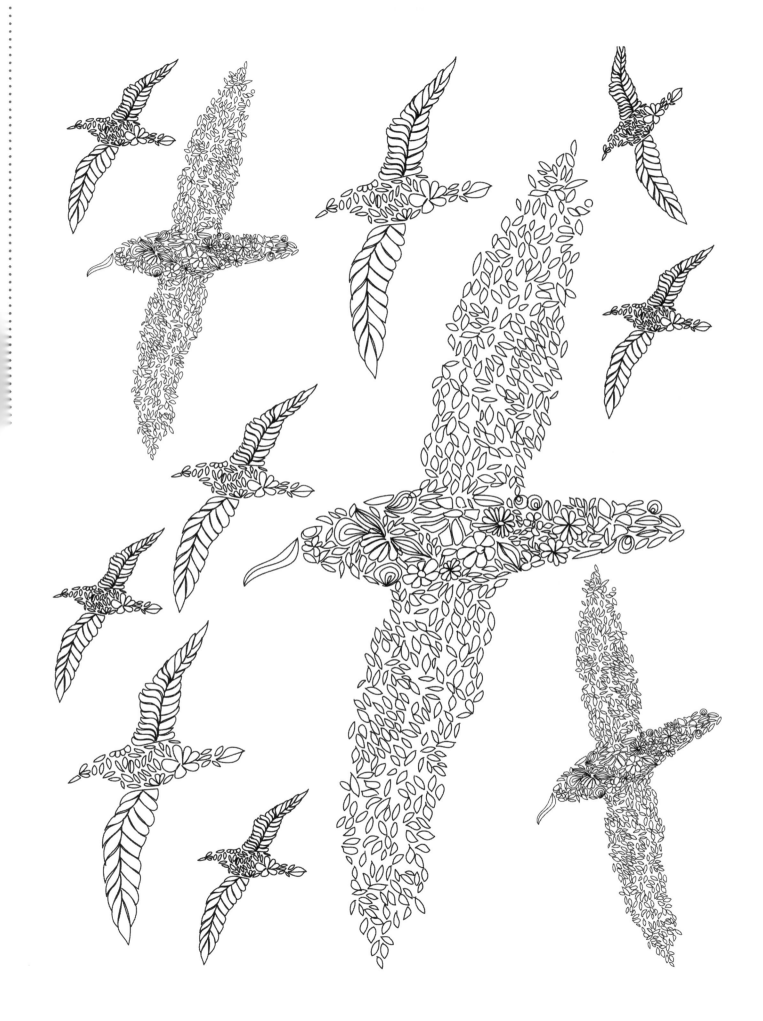

The earth is rude, silent, incomprehensible at first; Be not discouraged - keep on - there are divine things more beautiful than words can tell. there are divine things, well envelop'd; I swear to you there are divine things more beautiful than words can tell.

Walt Whitn

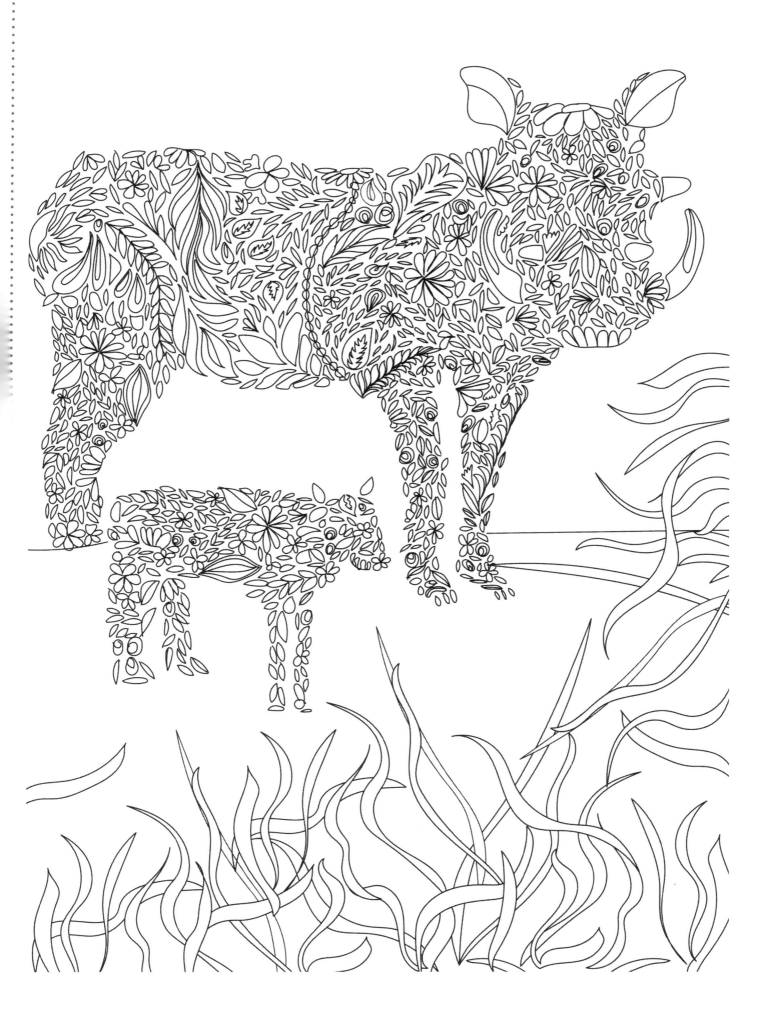

Let them look at the stars and the mountains above. Let them look at the waters and the trees and flowers on Earth. Then they will begin to think, and to think is the beginning of a real education.

David Po

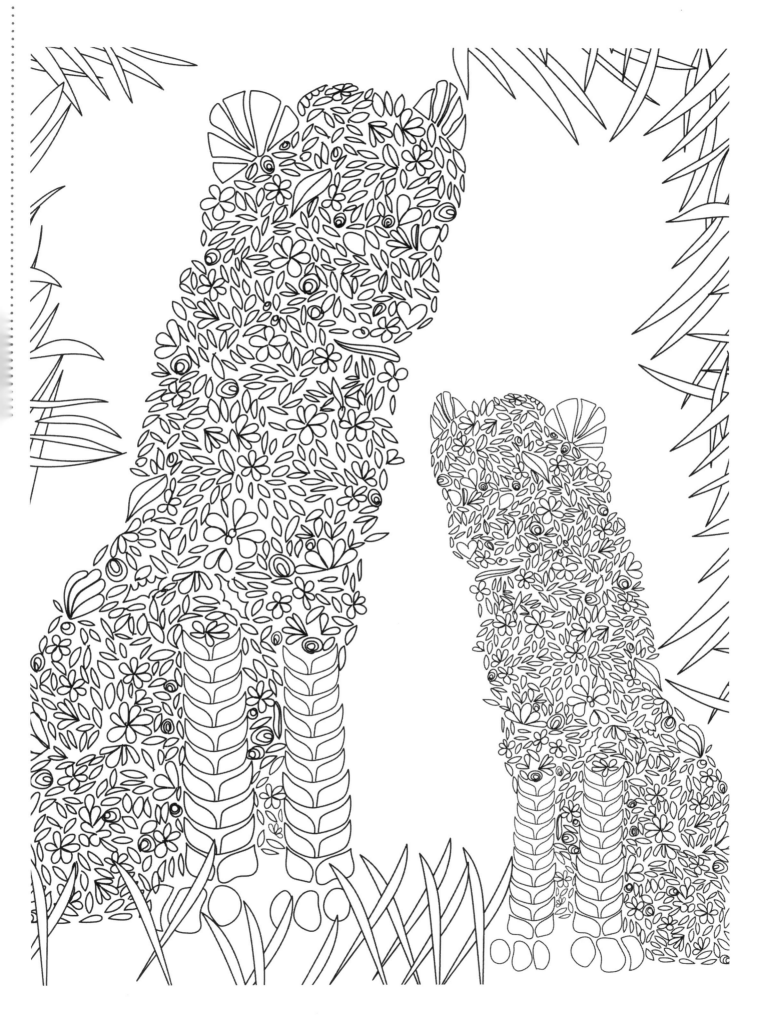

Of all the wonderful things in the wonderful universe of God, nothing seems to me more surprising than the planting of a seed in the blank earth and the result thereof.

Celia Thax

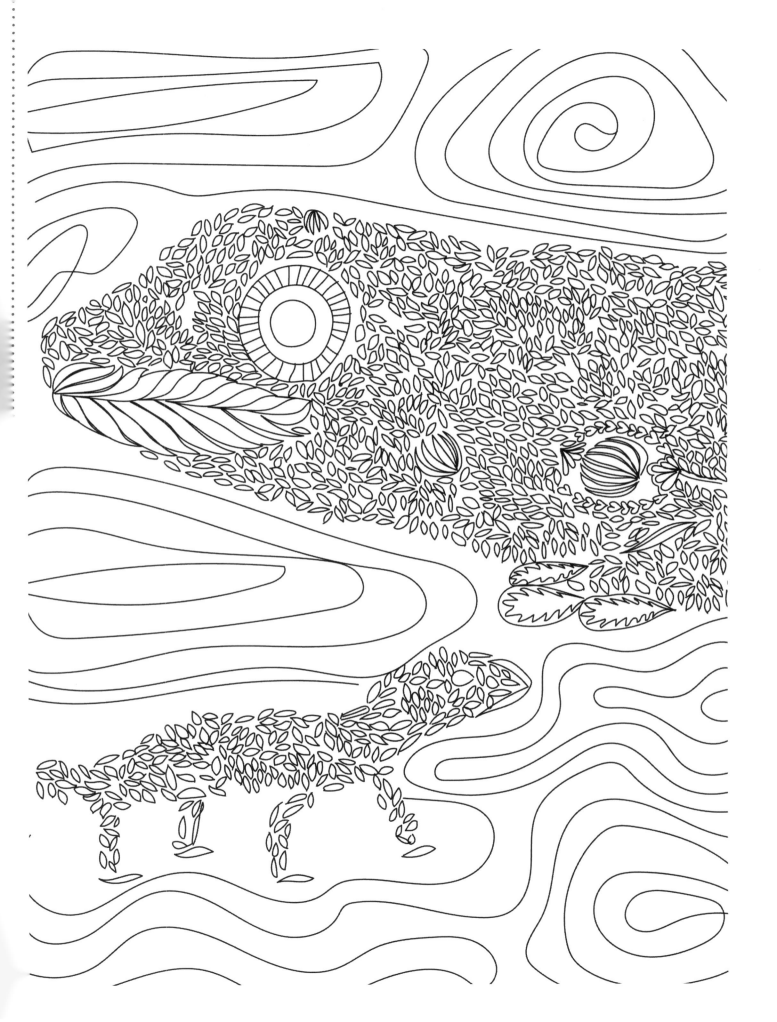

I want to realize brotherhood or identity not merely with the beings called human, but I want to realize identity with all life, even with such beings as crawl on earth.

Mahatma Gan[dhi]

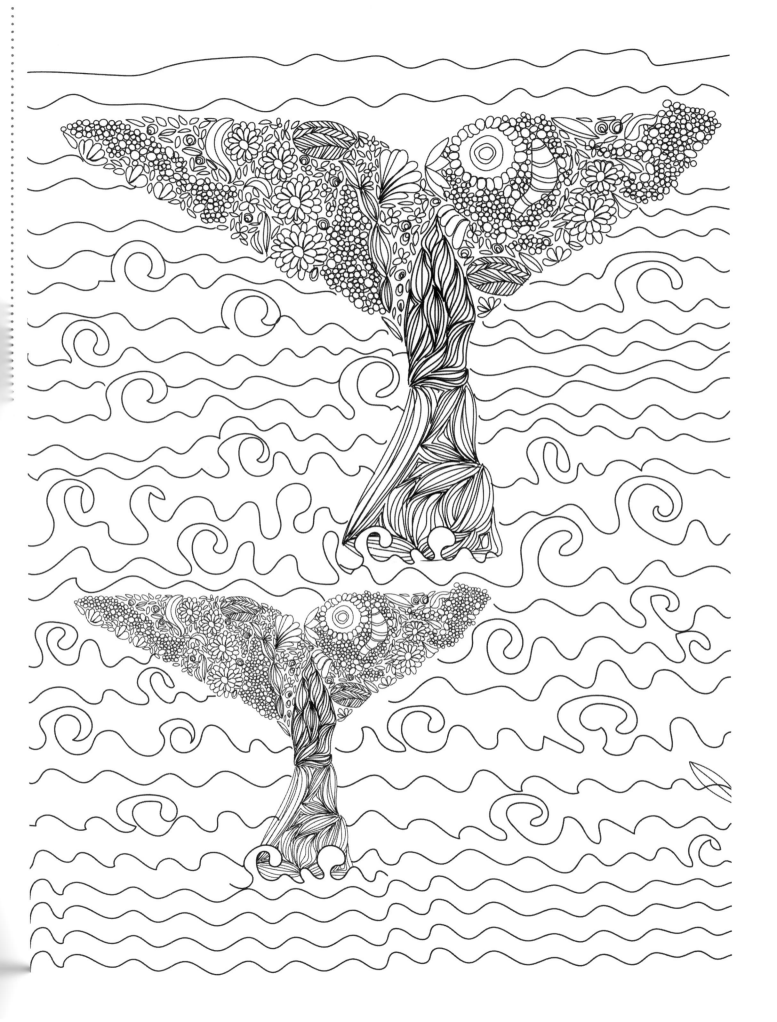

As long as I live, I'll hear waterfalls and birds and winds sing. I'll acquaint myself with the glaciers and wild gardens, and get as near the heart of the world as I can. I'll interpret the rocks, learn the language of flood, storm, and the avalanche.

John M

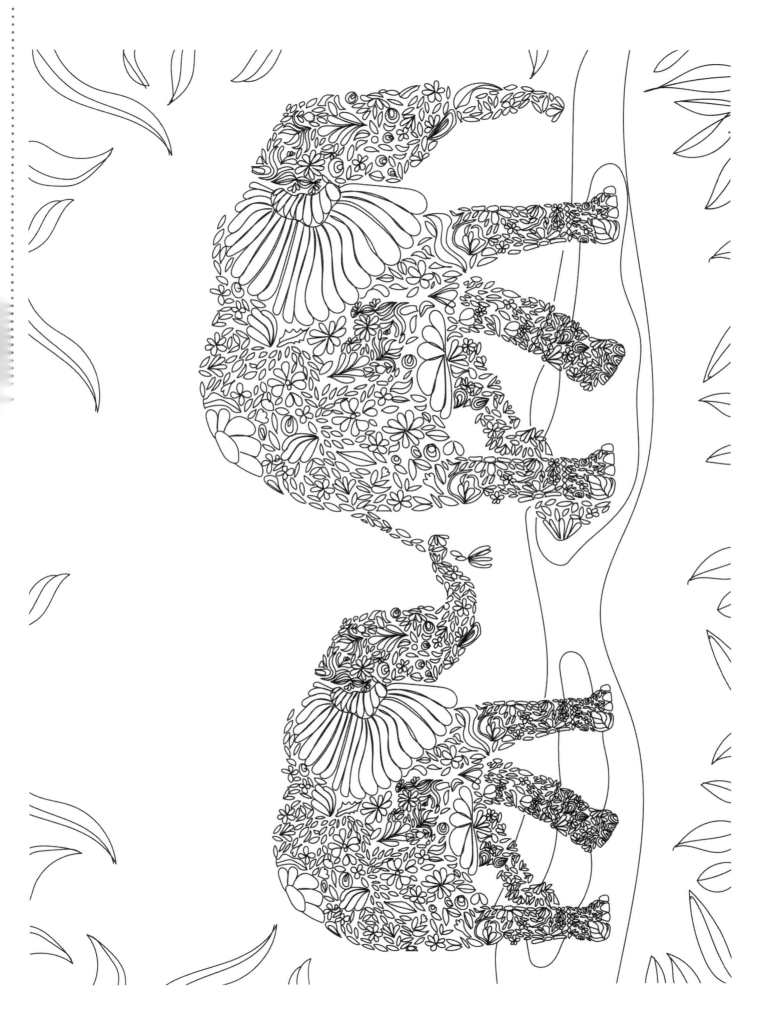

Beauty doesn't have to be about anything...what's a sunset or a flower about?

Douglas Ada

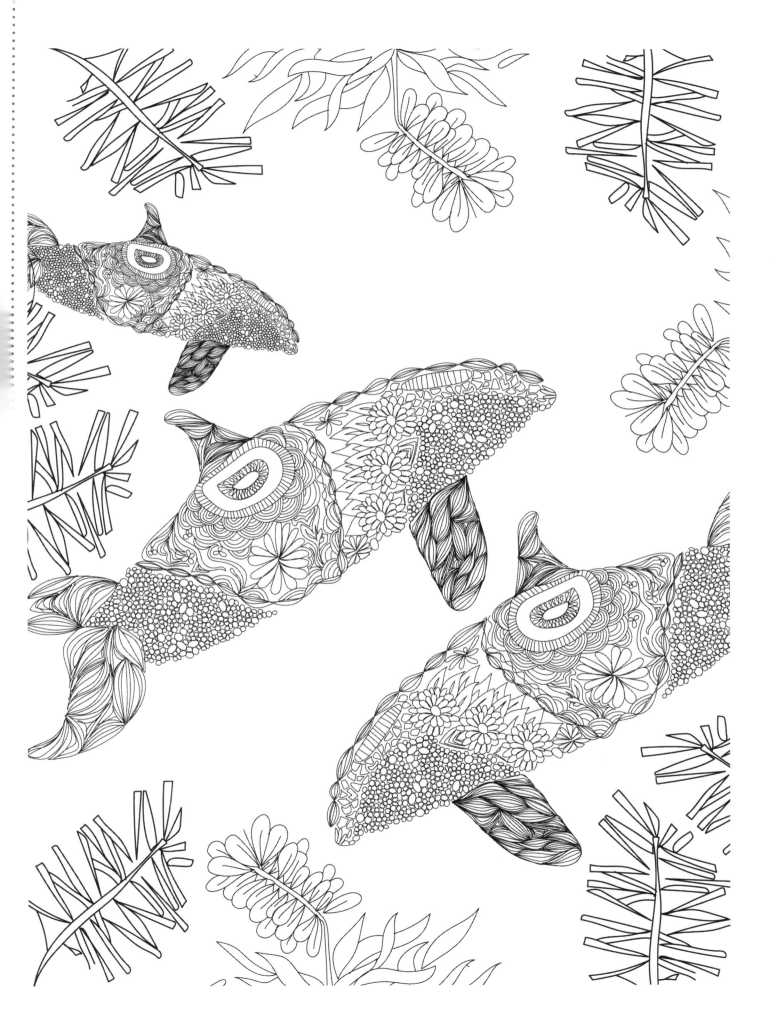

To watch the dawn emerge from the night undoubtedly gives a heavenly feeling;

Supriya Kaur Dhaliw

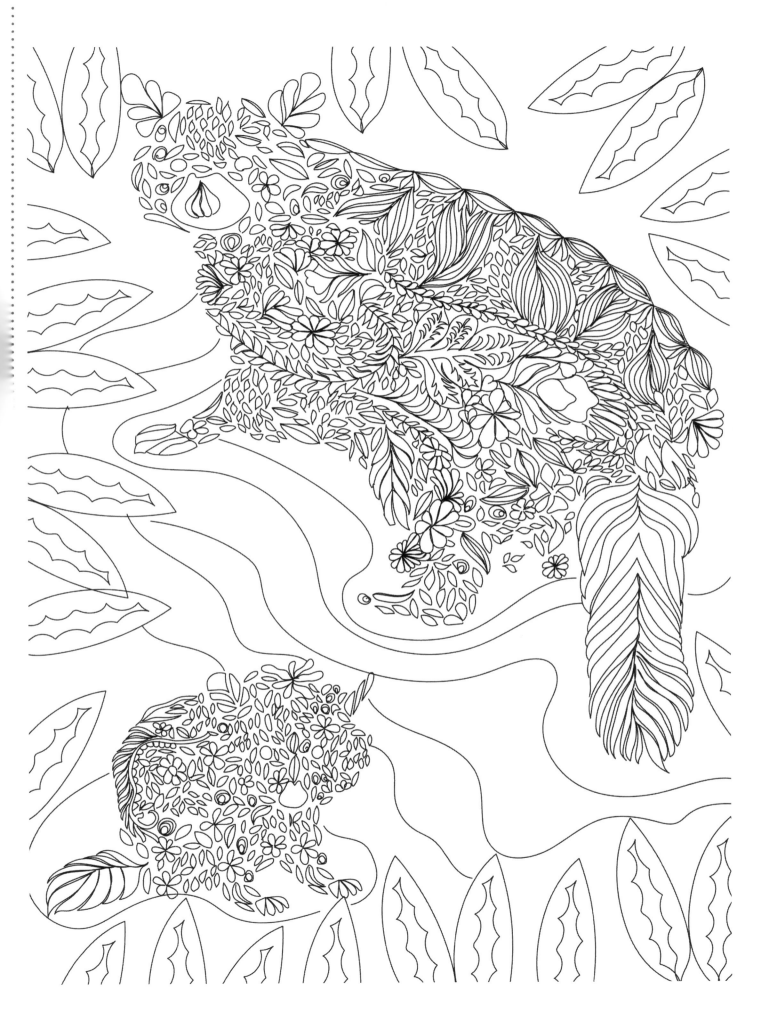

Nature is man's teacher. She unfolds her treasure to his search, unseals his eye, illumes his mind, and purifies his heart; an influence breathes from all the sights and sounds of her existence.

Alfred Billings Str

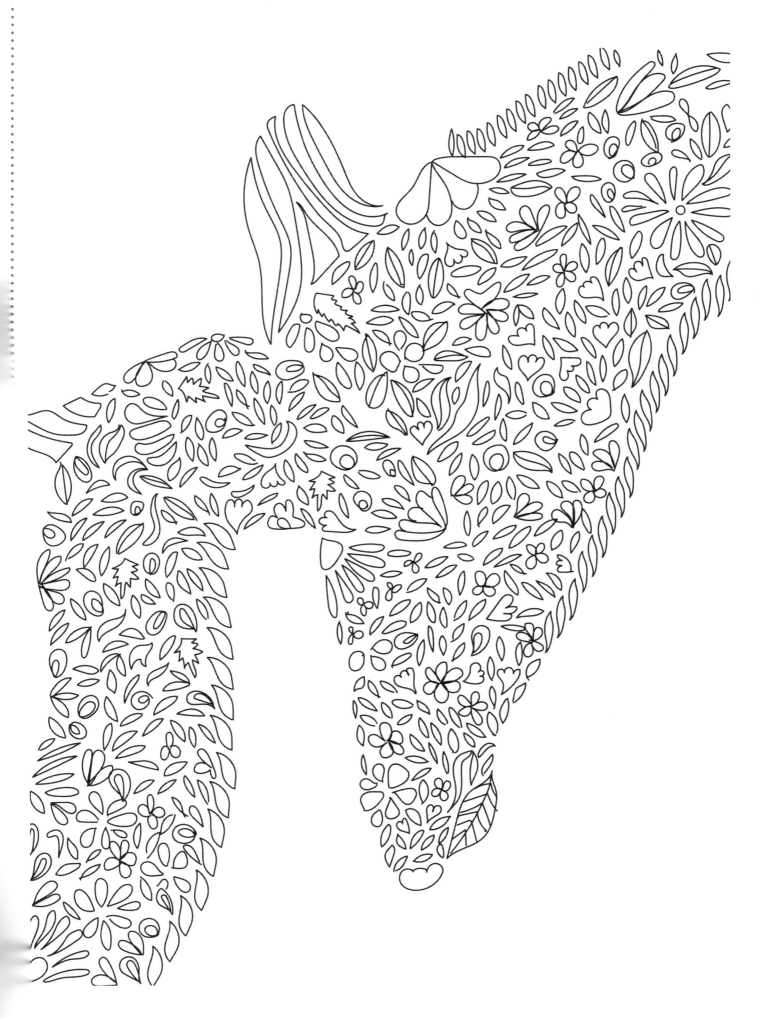

Beauty is the purest feeling of the soul. Beauty arises when soul is satisfied.

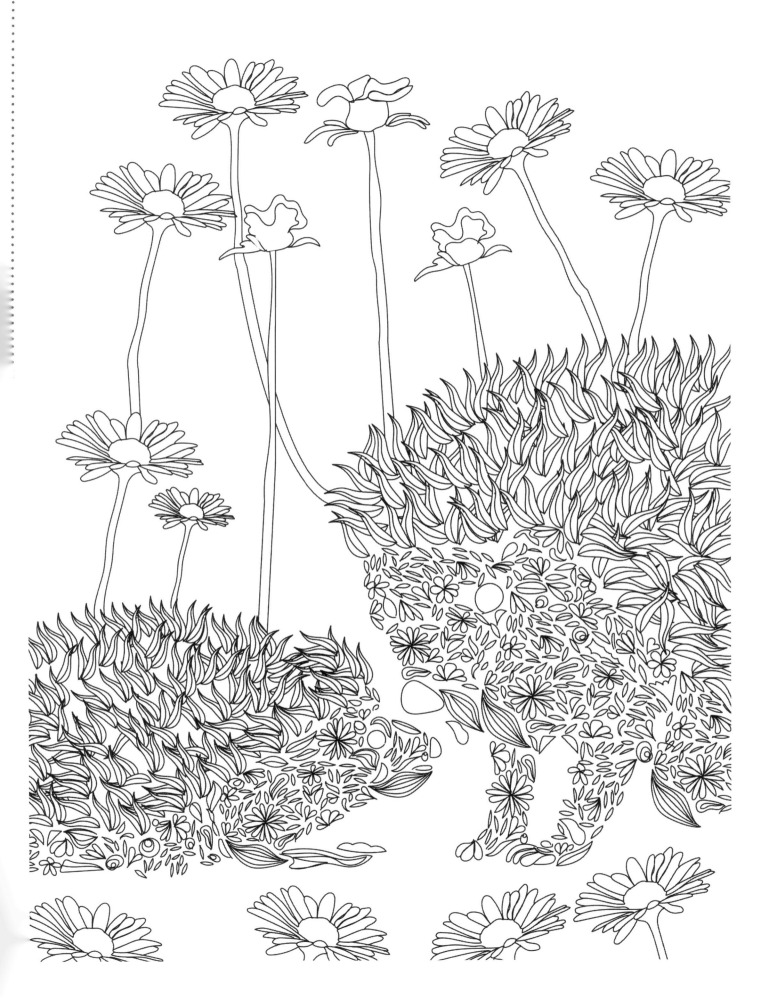

Look! Look! Look deep into nature and you will understand everything.

Albert Einst

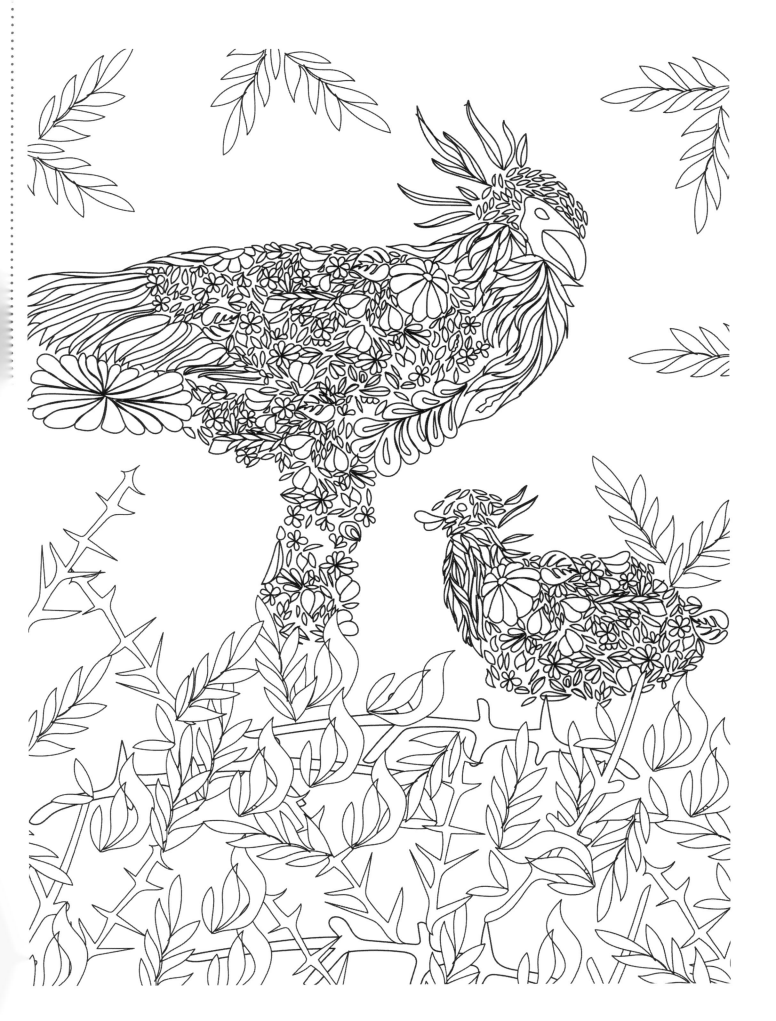

There is something infinitely healing in the repeated refrains of nature — the assurance that dawn comes after night, and spring after winter.

Rachel Carson

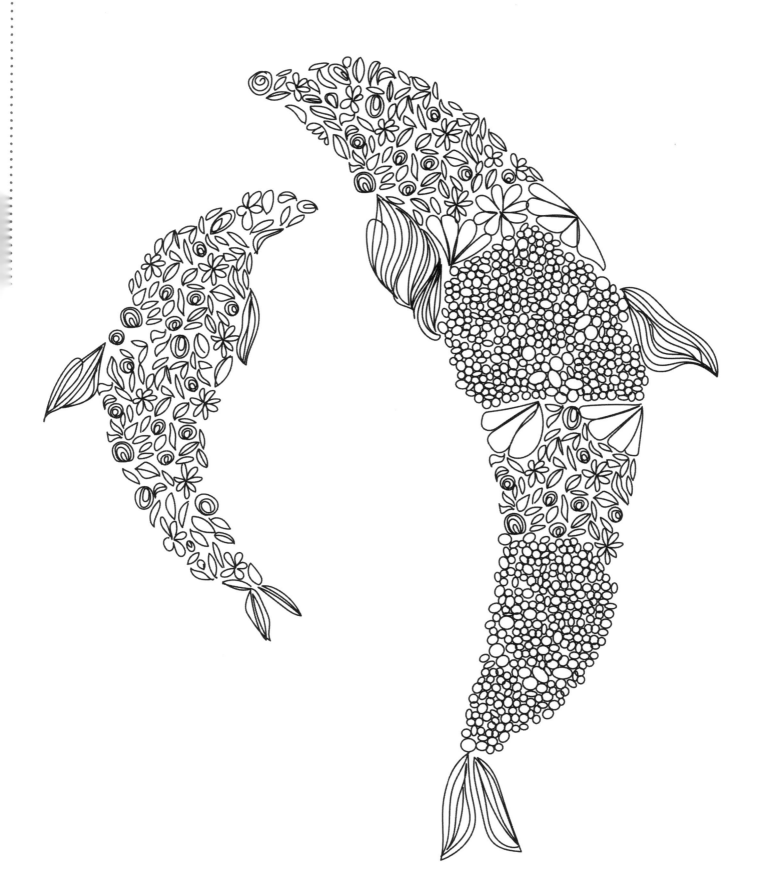

Eternal sunrise, eternal sunset, eternal dawn and gloaming, on sea and continents and islands, each in its turn, as the round earth rolls.

John M

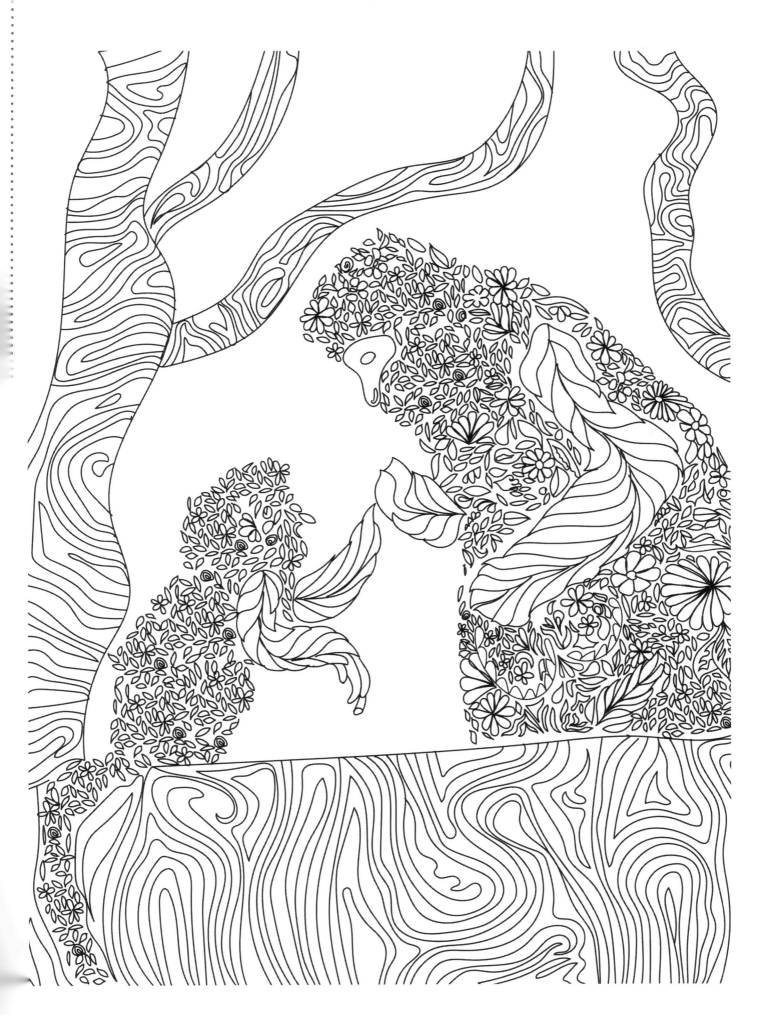

Nature's first green is gold, her hardest hue to hold. Her early leaf's a flower; But only so an hour. Nothing gold can stay. Then leaf subsides to leaf. So Eden sank to grief, so dawn goes down to day.

Robert Fr

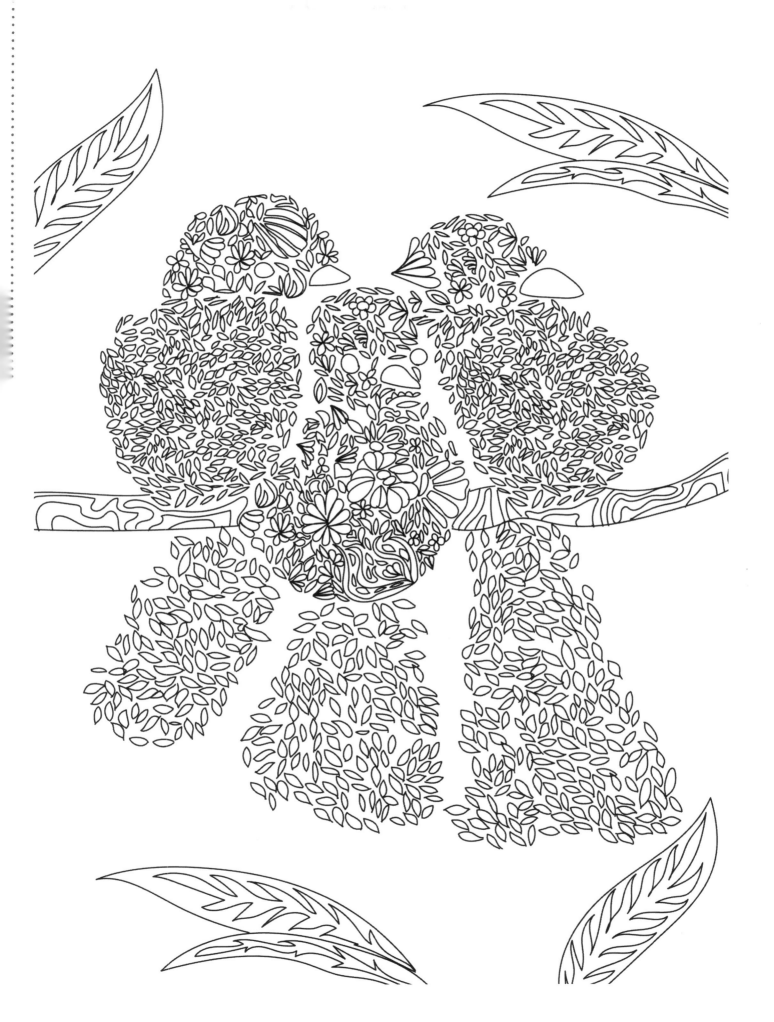

To sit in the shade on a fine day, and look upon verdure, is the most perfect refreshment.

Jane Aus

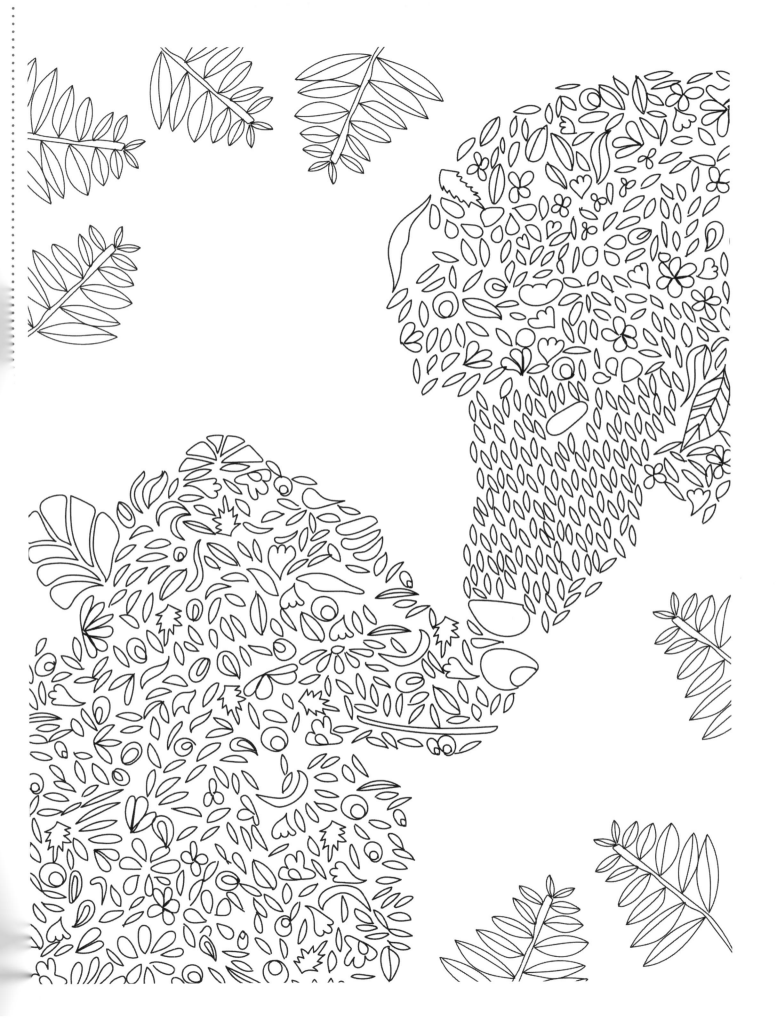

Those who contemplate the beauty of the earth find reserves of strength that will endure as long as life lasts.

Rachel Carson

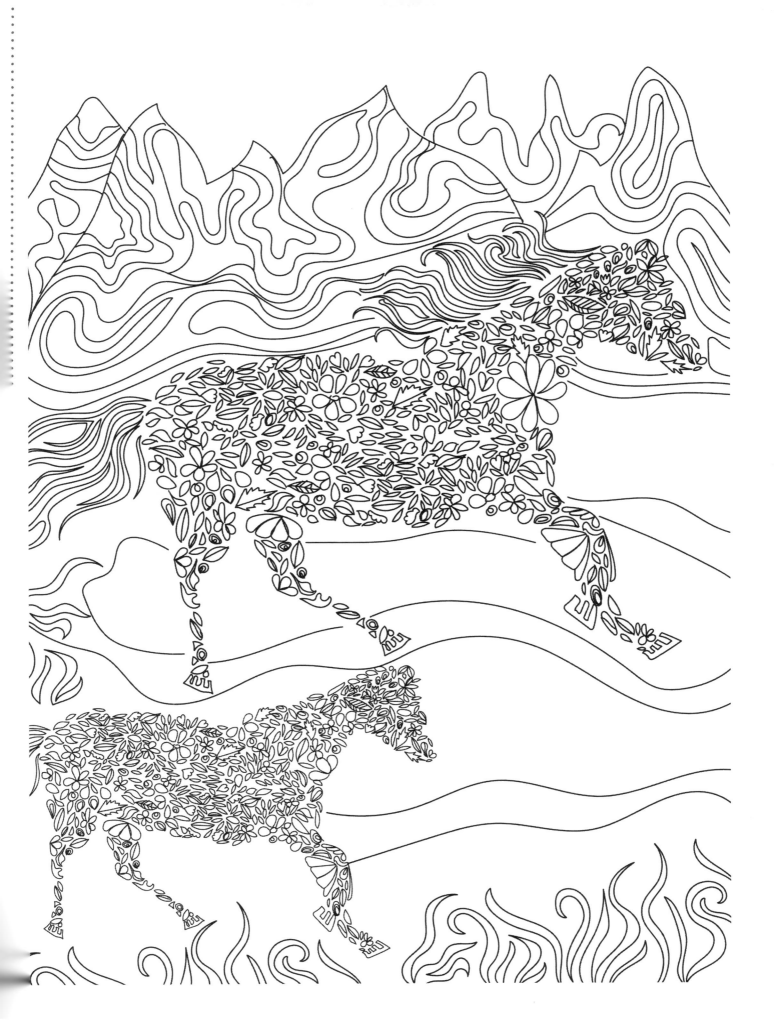

Their teachers have been the birds themselves, when they sang to them, the sun when it left a glow of crimson behind it at setting, the very trees, and wild herbs.

Anton Chekhov

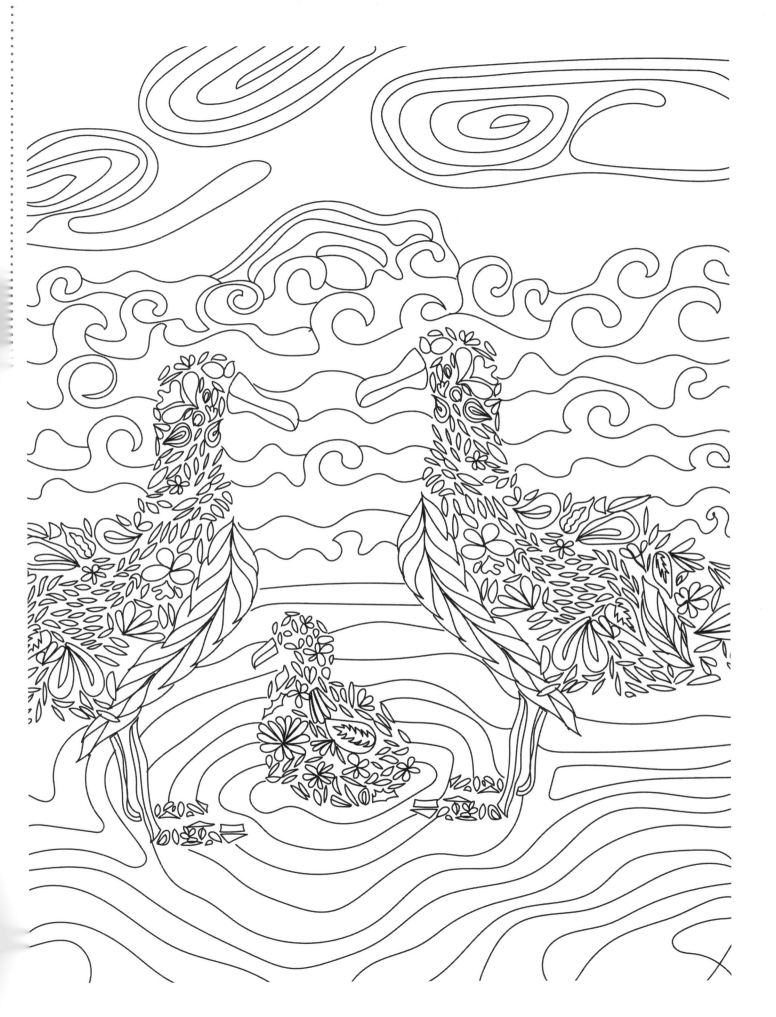

Printed in Poland
by Amazon Fulfillment
Poland Sp. z o.o., Wrocław